LISA FONSSAGRIVES

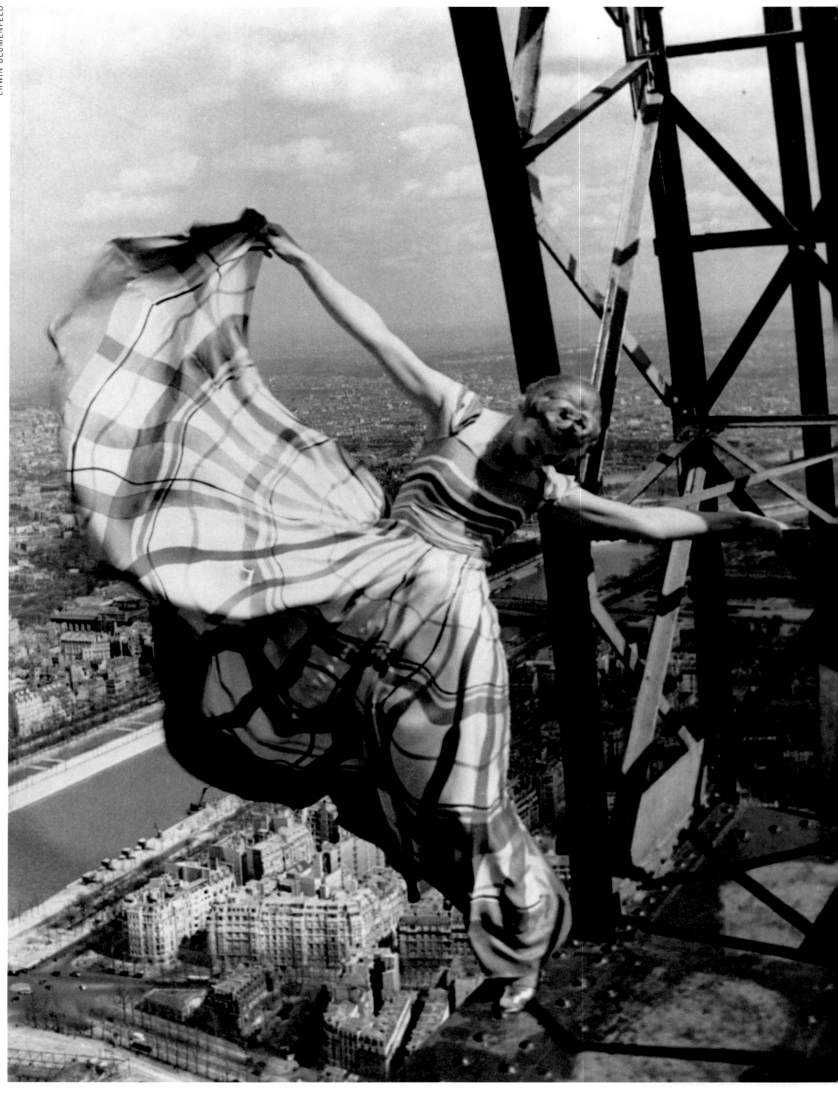

LISA FONSSAGRIVES

THREE DECADES OF CLASSIC FASHION PHOTOGRAPHY

EDITED, DESIGNED AND WITH AN INTRODUCTION BY
DAVID SEIDNER

WITH A TEXT BY
MARTIN HARRISON

PROJECT CO-ORDINATOR
DIANA EDKINS

THE VENDOME PRESS

ACKNOWLEDGMENTS

WE WOULD LIKE TO THANK: JAMES ABBE, KATHRYN ABBE, SANDY ARROWSMITH, RICHARD AVEDON, LILLIAN BASSMAN, YORICK BLUMENFELD, FIONA COWAN, LYDIA CRESSWELL-JONES, SHELLEY DOWELL, GENE FENN, ANTHONY HOLMES, RICHARD J. HORST, PETER C. JONES, FRANCES MCLAUGHLIN-GILL, ROBIN MUIR, DIANNE NILSEN, PAMELA RISIO, EUGENE RUBIN, PETER SCHUB, IRVING SOLERO, CARRIE SPRINGER, ETHLEEN STALEY, ANKE TRIPPE, TAKI WISE. SPECIAL THANKS TO FERNAND FONSSAGRIVES, HORST AND IRVING PENN.

LOTHAR SCHIRMER AUTUMN 1996

PUBLISHED IN THE USA IN 1996 BY THE VENDOME PRESS, 1370 AVENUE OF THE AMERICAS, NEW YORK, NY 10019 · DISTRIBUTED IN THE USA AND CANADA BY RIZZOLI INTERNATIONAL PUBLICATIONS THROUGH ST. MARTIN'S PRESS 175 FIFTH AVENUE NEW YORK, NY 10010

JACKET: HARLEQUIN DRESS BY JERRY PARNIS, NEW YORK 1950
PHOTOGRAPH BY IRVING PENN PUBLISHED IN VOGUE, APRIL 1, 1950 (FRONT)
»L'OEIL – THE EYE«, NEW YORK 1954
PHOTOGRAPH BY FERNAND FONSSAGRIVES (BACK)
ENDPAPERS: HUNTINGTON, LONG ISLAND 1951
PHOTOGRAPHS BY FRANCES MCLAUGHLIN-GILL

HARRISON, MARTIN, 1945 – LISA FONSSAGRIVES, A PORTRAIT/ EDITED BY DAVID SEIDNER ; WITH AN ESSAY BY MARTIN HARRISON. P. CM. · ISBN 0-86565-978-8 1. FASHION PHOTOGRAPHY–HISTORY–20TH CENTURY. 2. FONSSAGRIVES-PENN, LISA. I. SEIDNER, DAVID, 1957– TR679, H374 1996 659. 1 '52–DC20 [B] 96-18030 CIP

SEPARATIONS BY NOVACONCEPT, BERLIN · PRINTED IN ITALY BY EBS, VERONA
ISBN 0-86565-978-8 A SCHIRMER/MOSEL PRODUCTION

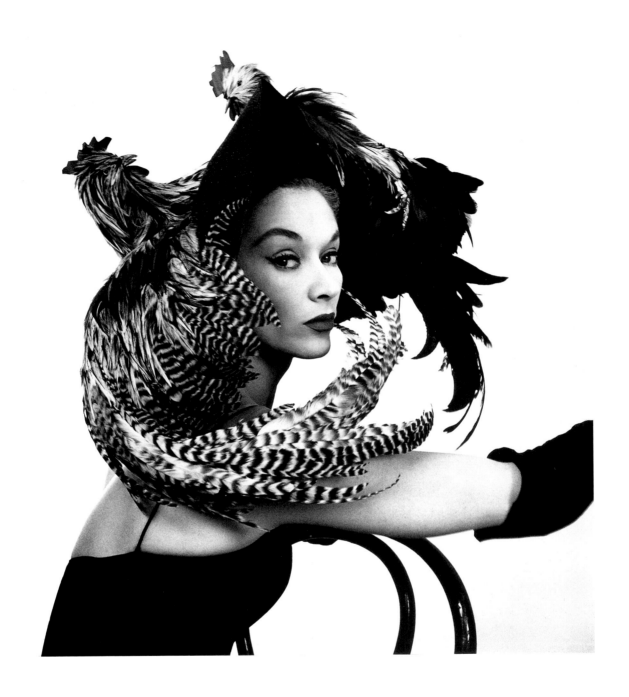

THE PHOTOGRAPHERS

RICHARD AVEDON LILLIAN BASSMAN

ERWIN BLUMENFELD ANTON BRUEHL

CLIFFORD COFFIN LOUISE DAHL-WOLFE

ANDRÉ DURST GENE FENN

FERNAND FONSSAGRIVES HORST

GEORGE HOYNINGEN-HUENE MAN RAY

HERBERT MATTER FRANCES MCLAUGHLIN-GILL

JEAN MORAL NORMAN PARKINSON

IRVING PENN GEORGE PLATT LYNES

EUGENE RUBIN RICHARD RUTLEDGE

IN LOVING MEMORY OF LISA FONSSAGRIVES-PENN

STILL DANCE
DAVID SEIDNER

'It is difficult to imagine the history of fashion photography without thinking of Lisa Fonssagrives-Penn. The image of the woman perilously hanging off the Eiffel Tower by Blumenfeld, the mermaid in the Rochas dress by Penn, the sleek, svelte, Swedish blonde greyhound with painfully high cheekbones and chiseled features, shoulders rounded, pelvis tucked in, the feet posed perpendicular with a well-turned ankle … the role model of the chic fifties woman, propelled by an elegant dynamism that we can only look at today with longing. Gone the days of a finely crafted gown, of an entire day to do one photograph, of the woman who can best do her own makeup ("a makeup artist has never touched my face"). Gone the days of eccentric fashion editors who use words like "dreamy" and "divine" and expound on the wonders of the little black dress. Gone the notion of the well-turned ankle.'

These words comprised part of the introduction to an interview I did with Lisa in 1984, published in the art magazine *BOMB* in the winter of 1985. In the course of lecturing on the history of fashion photography, I noticed this extraordinary presence reappearing in some of the best photographs of the greatest magazine photographers of the 1930s, 1940s, and 1950s. It was Lisa, consummate muse and chameleon, whose image burned on the pages. Horst, Penn, Huene, Blumenfeld, Parkinson, and a host of others in a list too long to mention, all made many of their most memorable images with this woman. It couldn't have been an accident. What was it that set her apart, that made her face as recognizable as the *Mona Lisa* to three decades of magazine readers? From 1936 to well into the 1950s, it was difficult to open an issue of *Vogue* or *Bazaar* without finding Lisa in it. Always exotic, yet slightly plump and wholesome when she began modelling at eighteen, she grew more and more ravishing as she grew older; at the height of her modelling career, at the apogee of her beauty, she was nearly forty. Her features became sharp and memorable, every plane jutted and recessed like some cubist sculpture, a photographer's dream. She was drawn with a knife

and could have decorated the prow of many a ship. She graced the cover of *Time*, became her own agent, introduced the idea of an hourly fee, and became an icon of theatrical elegance and grace.

Before the 1930s, fashion had been represented by illustration, and occasional photographs of aristocrats, high society, and a few celebrities. The first 'fashion' photographs are perhaps of the eccentric nineteenth-century Comtesse de Castiglione, whose taste for masquerade and burlesque pushed her into commissioning countless photographs of herself in fancy dress for her personal delectation (she is the woman in the Metropolitan Museum's collection whose eye we see behind the oval frame). Eventually, the Baron de Meyer's vaporous pictures of the likes of Gertrude Vanderbilt Whitney in Baskst in the 1910s and 1920s came to dominate the printed page. And we begin to get a hint of the idea of a 'model' with Steichen's art-deco siren, Marion Moorehouse (later Mrs E. E. Cummings). But as fashion proliferated, so the industry needed reliable representatives. Any photographer who has ever photographed a celebrity will have tales to tell of capriciousness. The pictures for the magazines had to get done, deadlines met, hence the dawn of the modelling profession. Enter Lisa. It is probably safe to say that Lisa was the first recognizable 'model'. This, of course, was long before the advent of the super-model; Lisa would have never put up with life in the limelight. She was most comfortable being barefoot in the country, the personification of some marvellous Swedish fable, a kind of wood nymph – more the embodiment of the elements, somehow, than of an earthbound human being. Lisa was almost immaterial. That's not to say insubstantial because her depth and cultivation were incomparable, but she had a whiteness and a transparency about her that made her seem ethereal. Over an eight-year period, I was blessed with having this miraculous spirit grace my life; constant letters, conversations, meetings. Our connection often seemed telepathic. She called it a special deep friendship and

I thought of it more like a platonic love affair. She was the sister I wished I could have had, and the mother I could only dream of. The qualities that made Lisa an extraordinary person are the same qualities that made her a remarkable model. She once said in a letter that honesty, dignity and grace were all that she needed in life.

What comes across in the photographs is an exceptional openness, a quality of trust and ease, a spontaneity, and an acute intelligence in the eyes. There is a thorough grasp of the idea of the unfinished movement, similar to freeze-frame, something very few models can achieve – that millisecond before an action is complete which allows the viewer of the photograph to complete it, providing a kind of narrative, a reading of the image on several levels. Often she has just a hint of a smile – not a real smile or any kind of forced expression, but a genuine joy and optimism generated from within. One finds it throughout the entire history of art, beginning with the archaic smile of the Kouros of ancient Greece, through the Italian primitives and into the Renaissance, throughout great Northern European painting of the seventeenth and eighteenth centuries, and in the sublime portraits of Ingres and David (Lisa is a perfect *Madame Recamier* in Huene's beautiful homage). It was Lisa's selflessness, her lack of ego and pretension, that allowed her to assume any role the photographer chose to cast her in, and to be thoroughly convincing. She was guileless – no lurid stories or intrigues, no amusing anecdotes. She was one of those rare people in this world who made other people feel valuable because of their differences. Her encouragement was always in the future tense – 'you will succeed', 'you will find love' – and her optimism and belief were contagious. Her enthusiasm at times bordered on naïve but you wanted to – and did – believe in all her predictions because she seemed to foresee the future by extrapolating from the present. She gave a voice and presence to uniqueness, and through her own wayward existence, set an enviable example. 'I never

PAGE 2: FASHION BY LUCIEN LELONG, EIFFEL TOWER, PARIS, 1939. PHOTOGRAPH BY ERWIN BLUMENFELD, FRENCH VOGUE, MAY 1939
PAGE 5: WOMAN IN CHICKEN HAT, NEW YORK, c. 1949. PHOTOGRAPH BY IRVING PENN – PAGE 10: FASHION BY JEAN DESSÉS, LA BAHIA PALACE IN MARRAKECH, MOROCCO, 1951. PHOTOGRAPH BY IRVING PENN, VOGUE, JANUARY 1952

thought of having or making a career. I've just been floating through life enjoying it almost all the time. I think we are destined (chemical compositions that program us) so don't try so hard, you too will float in and out of creative actions.' She was clever and adaptable with great deference to others and not even a hint of opportunism. She was the personification of glamour without a trace of vanity. I don't have even a single recollection of Lisa ever stopping in front of a mirror.

Her image was formed by others but she was never passive in the depiction of her likeness; she was keenly aware of light, composition, suspended gesture. She thought of her modelling work as a continuation of dance, 'still dance' she called it. From dancing to modelling to sculpting, her approach stemmed from a deep belief in 'the mysteries' and what she considered to be a pagan communication with nature. A description Lisa wrote of her method of sculpting could be perfectly applied to her method of modelling: 'When I work on sculpture I go into a state of blankness, of emptiness, where I don't think any more. It's a suspension of shapes and forms. It's only feeling that I want to express and the mood. It's a desire to bring out of myself the vibrations of those feelings. The vibrations take over and create the form, as an echo of what I have inside.'

Lisa Bernstone left Stockholm in 1931 to study dance with Mary Wigman in Berlin. Wigman was a revolutionary modern-dance choreographer who began a sort of direct communication with the ground, in diametric opposition to classical ballet's attempt to escape it, and very unlike what was thought to be modern dance at the time: Isadora Duncan's lofty, poetic celebrations of ancient Greek dances derived from vase painting and ritual. Lisa's parents, both doctors and enthusiasts of the arts, encouraged her to go to Berlin after Lisa had written to Wigman to inquire about her classes and was invited to enroll. On her return to Stockholm, she founded a school of dance with a fellow Swede named Astrid Malmbörg. They entered an international competition in Paris where they won an honourable mention. Lisa fell in love with the city

and decided to stay and study other forms of dance besides modern. She met her first husband, Fernand Fonssagrives, also a dancer, while studying with a white Russian named Princess Egorova. Together, Fernand and Lisa gave classes and danced with different companies. During rehearsal with a German choreographer, Lisa was spotted by the fashion photographer Willy Maywald (best known as the house photographer for Dior and Fath), who asked her to do a sitting in hats. Practically the next day, Fernand took the pictures up to *Vogue* where she was instantly booked to do a sitting with Horst. She said she arrived terrified wearing a brown wool suit of her own design, with 'wild hair'. 'But it was my hands that troubled me most. What to do with one's hands…' The next day she went straight to the Louvre to study how differently dressed people posed. This was in 1936, and Lisa's career as a model was not only born, but took off. She said she would study herself in the dressing-room mirror and instinctively try to solve the photographer's problems, looking at the cut of the dress and how the light would best enhance it, 'trying to create a line, the way one would start a drawing.' She would ask to see contacts after sittings to assess her successes and shortcomings, referring to herself in the third person as 'that girl', always looking for the strongest photograph (as opposed to where she looked prettiest), intent on improving herself the next time. She hated the word 'shooting' which she found one-sided and impersonal: 'It was never a shooting, but a "sitting"… a collaboration… and making a beautiful picture is making art isn't it?'

When Fernand was injured and could no longer dance, Lisa gave him a Rolleiflex while he was recuperating. He began taking pictures, and between the fashion collections, there were endless vacations together. Fernand photographed Lisa frolicking on the beach and sunbathing naked, diving and scaling rocks, and sold the pictures to magazines like *Jeunesse d'Aujourd'hui* throughout Europe. 'In those days, a picture didn't have to be assigned to be published; if it was beautiful, the magazines would run it.' They were on their way to New York when war was declared, and decided to stay in America.

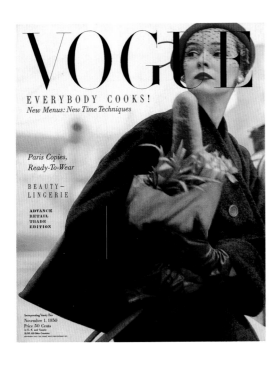

VOGUE

EVERYBODY COOKS!
New Menus: New Time Techniques

*Paris Copies,
Ready-To-Wear*

**BEAUTY–
LINGERIE**

ADVANCE
RETAIL
TRADE
EDITION

Incorporating Vanity Fair
November 1, 1950
Price 50 Cents
in U.S. and Canada
$1.00 All Other Countries

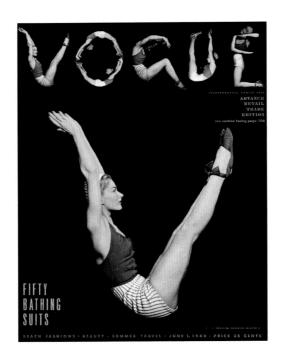

VOGUE

INCORPORATING VANITY FAIR

ADVANCE
RETAIL
TRADE
EDITION

see section facing page 106

**FIFTY
BATHING
SUITS**

BEACH FASHIONS · BEAUTY · SUMMER TRAVEL · JUNE 1, 1940 · PRICE 35 CENTS

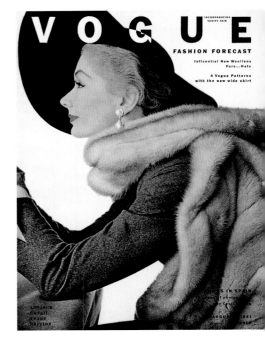

VOGUE
INCORPORATING VANITY FAIR

FASHION FORECAST

Influential New Woollens
Paris...Hats

4 Vogue Patterns
with the new wide skirt

ADVANCE
RETAIL
TRADE
EDITION

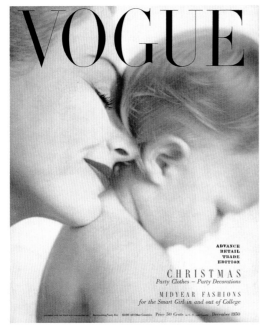

VOGUE

ADVANCE
RETAIL
TRADE
EDITION

CHRISTMAS
Party Clothes – Party Decorations

MIDYEAR FASHIONS
for the Smart Girl in and out of College

Incorporating Vanity Fair · $1.00 All Other Countries · Price 50 Cents in U.S. and Canada · December 1950

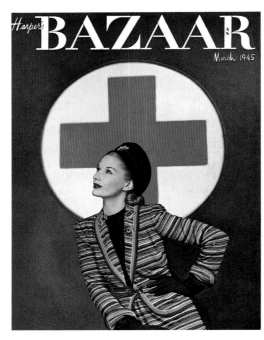

Harper's **BAZAAR**
March 1945

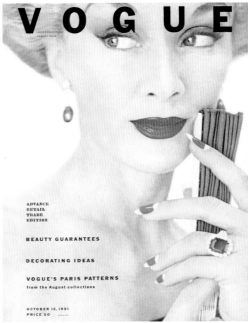

VOGUE
INCORPORATING VANITY FAIR

ADVANCE
RETAIL
TRADE
EDITION

BEAUTY GUARANTEES

DECORATING IDEAS

VOGUE'S PARIS PATTERNS
from the August collections

OCTOBER 15, 1951
PRICE 50

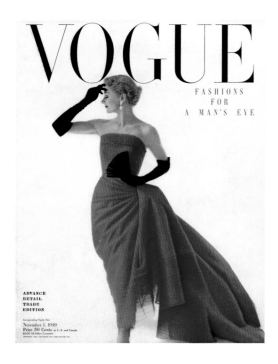

VOGUE

**FASHIONS
FOR
A MAN'S EYE**

ADVANCE
RETAIL
TRADE
EDITION

Incorporating Vanity Fair
November 1, 1949
Price 50 Cents in U.S. and Canada
$1.00 All Other Countries
COPYRIGHT 1949, THE CONDÉ NAST PUBLICATIONS INC.

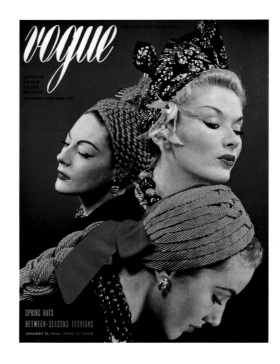

Vogue
INCORPORATING VANITY FAIR

ADVANCE
RETAIL
TRADE
EDITION

see section facing page 102

**SPRING HATS
BETWEEN-SEASONS FASHIONS**

JANUARY 15, 1940 · PRICE 35 CENTS

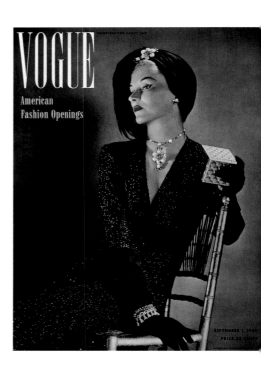

VOGUE
INCORPORATING VANITY FAIR

**American
Fashion Openings**

SEPTEMBER 1, 1944
PRICE 25 CENTS

VOGUE

MAY I

THE UNSPENT SUMMER:

FASHION TIP SHEET

**ADVANCE
RETAIL
TRADE
EDITION**

Lisa began taking her own photographs for *Ladies' Home Journal*. After her marriage with Fernand 'eventually dissolved', she lived in a rambling old apartment on Central Park West with a darkroom that became a nursery after she married Irving Penn. Having to order her prints from commercial photography labs, she had trouble meeting deadlines, and decided to 'give it up'. She continued modelling well into the 1950s, mostly for American *Vogue*, and then began designing an occasional dress for one of Irving's advertising campaigns. This turned into a line of 'at home' clothes (later sportswear too) for the department store Lord and Taylor for the next six years. But true to L.F.P. style, when the Penns had to move from Central Park West when the building was to be demolished (the dining room had been Lisa's atelier) and she was not allowed to conduct a business in their new apartment, she 'stopped'. She began spending more and more time in her sculpture studio at their house in the country, and enrolled at the Art Students League to hone her drawing skills. They finally moved to Long Island so that Lisa wouldn't have to commute and she devoted the rest of her life to making sculpture.

Although Lisa was remarkably direct, she had a kind of passive-aggressive approach to her careers. Basically there were three: dancer, model, sculptor, with brief stints as a photographer and clothing designer. The disciplines grew in and out of one another, organically formed more by circumstance than by ambition, without any real beginnings or endings but rather very blurred boundaries. She was loath to say she did anything professionally – not out of false modesty but real humility. Not only is there this remarkable collection of brilliant fashion photographs documenting one of our century's unique beauties, but she had a distinguished career

as a sculptor in the formal modernist tradition (organic abstraction via nature) and was represented for many years by the prestigious Marlborough Gallery, producing monumental bronzes and exquisitely refined etchings. There were no distinctions made between the different aspects of her work and life. She said there were dancing things in nature that inspired her enormously: 'Branches that sway in the wind, water crashing over the rocks in the sea'. And in her own movement, there was always the mastery of the body inherent to good dance and a sense of continuous line that one finds in classical sculpture: a series of contrasting diagonal planes that make for a harmonious, dynamic flow. This idea of continuous line can be followed from the first photographs of her in 1936 to her last artwork from 1991, uninterrupted.

Art was an important part of our relationship; we spent many afternoons together at the Metropolitan Museum or the Modern, wandering through the galleries. I can still see Lisa, nearly eighty, thin as a rail with her signature stance, suspended between Richard Serra's enormous steel plates on the floor and ceiling of a room at the Modern. It was somehow a fitting metaphor: this seemingly frail and delicate wisp of a thing completely unaware of the dramatic contrast.

I'll never forget walking through the door of the little Italian restaurant on the Upper East Side and seeing Lisa for the first time at what was to become our almost weekly corner table for lunch whenever I was in New York. Sitting erect in a white turtleneck sweater with a white fur toque on her head, she looked like some exotic princess of the steppes. She wouldn't let me use a tape recorder but I swear I can remember every word that came out of her mouth. She had this delectable old-world cadence about her

PAGE 14 (FROM LEFT TO RIGHT, TOP TO BOTTOM): COAT ADAPTED FROM ELSA SCHIAPARELLI. PHOTOGRAPH BY NORMAN PARKINSON, VOGUE COVER, 1 NOVEMBER 1950 – FASHION BY BRIGANCE, 1940. PHOTOGRAPH BY HORST, VOGUE COVER, 1 JUNE 1940 – FUR STOLE BY MAXIMILIAN. PHOTOGRAPH BY IRVING PENN, VOGUE COVER, 1 AUGUST 1951 – LISA AND TOM PENN. PHOTOGRAPH BY IRVING PENN, VOGUE COVER, DECEMBER 1950 – FASHION BY TRAINA-NORELL. PHOTOGRAPH BY LOUISE DAHL-WOLFE, HARPER'S BAZAAR COVER, MARCH 1945 – JEWELS BY VAN CLEEF AND ARPELS. PHOTOGRAPH BY CLIFFORD COFFIN, VOGUE COVER, 15 OCTOBER 1951 – FASHION BY LANVIN-CASTILLO. PHOTOGRAPH BY IRVING PENN, VOGUE COVER, 1 NOVEMBER 1950 – TURBANS BY LILLY DACHÉ. PHOTOGRAPH BY ANTON BRUEHL, VOGUE COVER, 15 JANUARY 1940 – FASHION BY SOPHIE GIMBEL. PHOTOGRAPH BY HORST, VOGUE COVER, 1 SEPTEMBER 1940. – PAGE 15: FASHION BY ADELE SIMPSON. PHOTOGRAPH BY IRVING PENN, VOGUE COVER, 1 MAY 1952

voice, distinctly Swedish, but not a caricature like something from a Bergman film, but a beautiful, aristocratic, sort of jaunty lilt, tinged with French and German, testament to a rich, intelligent life. She quoted Mallarmé, made references to Zen philosophy, talked a lot about great painters – in short that voice coupled with those slanted eyes full of compassion and understanding had me instantly smitten. Space travelling, and seeing all those years of incredible photographs unfolding before my eyes as she spoke, I began to lose myself in reverie, almost as if I were hearing her echoed or under water.

I was twenty-seven at the time, and Lisa was seventy-two – an unusual symmetrical equation. Lisa had the wisdom of the ages but retained a freshness and little-girl quality that contrasted starkly with my serious and at times depressive character. She used to tell me I was born with an old soul and I felt Lisa's was eternally young. We would have bouts of giggling about

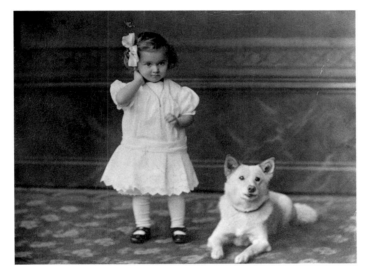

LISA BERNSTONE AT ABOUT THREE YEARS OLD. PHOTOGRAPH BY MARIA LUNDBÄCK, UDDEVALLA, SWEDEN

nothing in particular, and I would say: 'Stop it, you're so silly.' She told me no one ever dared to call her silly but that it was entirely true and she loved it. She also loved what she called our 'Sturm und Drang', and said it would never leave us. She said I would meet the challenge over and over. This was her advice in a letter: 'Keep the S und D, do not mature, maturity is rot, I don't believe in it, and too much thinking is harmful to your artistic health. One can't throw in the towel, that would be living death. It is here, in our private work we must stand, naked in honesty, in front of that tyrannical god, who is our soul – our heads bowed – reaching for that higher innocence required for the guest of art.' Lisa was a hopeless romantic with an acute sense of *weltschmerz*. I once told her I remembered writing in my journal that the romantic was constantly

endowing others with the qualities that he or she needed most, and as a result, constantly disappointed. She answered: 'The nature of the romantic is that there is always new glory waiting beyond every failure… We say in Sweden, beyond every sorrow await a thousand springs.'

These pronouncements she would often preface with: 'I hate to sound Pollyannaish, but …' She was the eternal optimist, always looking for the good, ignoring the bad. The only thing Lisa really hated was the heat: 'Summer is not my best time, I detest heat. The pool is lovely, our fifty-foot linden tree spreads its delicious perfume all around us – I look up under the branches and think of what magnificent things come out of the earth and what nonsense comes out of my brain… soon we shall meet again – I hope – and heal all scars, pains, thoughts of doubts with a blasting silliness session… tenderly L.' She used to say it was too hot to hold the pen in her hand, and too hot to work in her studio. But she exercised every morning and swam everyday when the weather permitted. From Sweden she complained that her hand was cramped from rowing the boat. She was well into her seventies. She was fearless, Lisa; the picture of her in the speeding sports car by Lillian Bassman is not faked. Nor are the many photographs of her on horseback, jumping a gorge with ski poles, sitting dangerously on the edge of a cliff, or hanging off the Eiffel Tower. The only reason she stopped flying her own plane was because she once had to make an emergency landing and was afraid of what would happen to her children if she were no longer around. She hated small-talk and social functions and only went to what she called 'command performances'. She had a special talent for being alone, which I think might very well

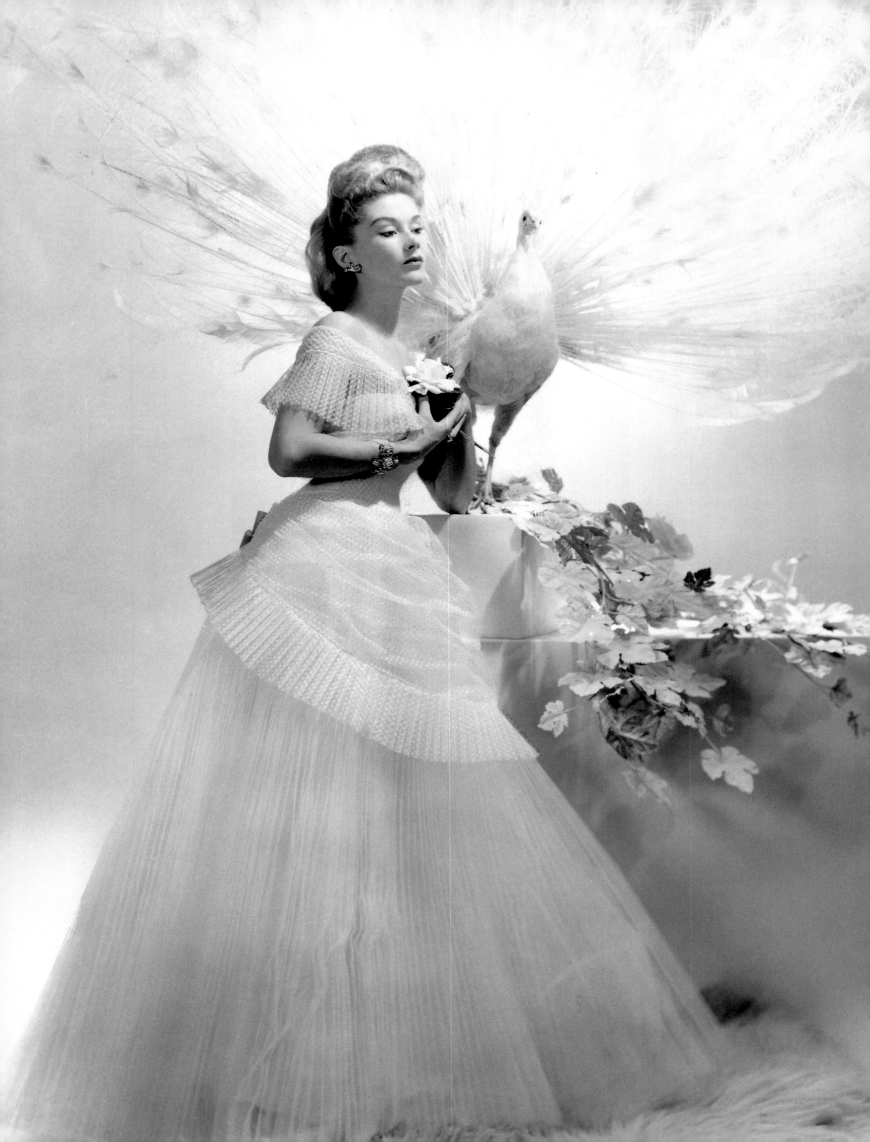

be a blessing of the Nordic peoples. She was most comfortable isolated in the countryside. She once wrote from Sweden: 'We are surrounded by water and islands on three sides and stillness – unbelievable stillness – no birds, no people, no sounds – there is so little space between sky and sea – the sea is a mirror – the sky falls into it with its mother of pearl clouds and soundlessly the light changes – the sun breaks through and for a minute or two caresses the islands – then darkness glides over them and gives them contrast against the water. These movements continue silently all through the day and one cannot stop watching in fascination. What do we do? Nothing. We watch.'

Her postcards were more often than not images of birds: seagulls, owls, swans, ducks. She loved birds; I think she secretly felt very much akin to them. It's somewhat ironic that she raised peacocks, one of the more earth-bound varieties. She had a great attachment to animals and defined distinct periods of her life by the pet she had at the time. How idyllic that image of Lisa by Irving Penn, lolling in tall grasses, a book in her hand, her dog at her side. How fitting that she lived on Sweet Hollow Road; 'Sweet Lisa of the Sweet Hollow' I once wrote to her. Her letters are full of constant references to 'soul-beauty', and she called me the mute recipient of her *sotto-voce* thoughts. She once asked me to tear up her letters, not because she was afraid of someone reading them one day, but because I once wrote that I felt guilty for not responding quickly enough. She signed most of her letters with 'stay close', a command not difficult to heed. In one of her last letters, she wrote: 'The last line in your letter: "I wish you would come so I can be myself" made me very happy. If I can make you feel *yourself* I shall have done something good: Parce que ce que j'ai voulu te donner n'est pas de ce monde-ci, mais de l'éternité …' (Because what I wanted to give you is not of this world, but of eternity).

Anyone who ever saw Lisa and Irving together could not help but be envious. After more than forty years of marriage, they still acted like newlyweds, constantly holding hands, almost cooing, looking at each other love-struck; their worlds revolved around each other, the devotion was total and complete. They lived in a modest country house in Long Island on beautiful grounds. In their upstairs bedroom, there was a huge plate-glass window giving onto acres of grasses and an enormous tree. Here, Irving brought breakfast to Lisa in bed every morning, and she, in turn, would drive him to and from the train station from which he commuted to his studio in the city. She spent her days in the sculpture studio working on casts and etchings. Dinner would be prepared and ready when Irving returned each evening. Lisa was extremely close to her family, to her daughter Mia from her first marriage to Fernand Fonssagrives, to Tom, her son with Irving, and to all of the extended family, in Sweden and America. Lisa and Irving had a house in Sweden, on an island, where she had gone since childhood, and to which they would retreat every summer and have large family gatherings.

Lisa and Irving met in New York, in the *Vogue* Studio at 480 Lexington Avenue. It was during the sitting of 'the twelve most photographed models of 1947', a well known Penn photograph. Lisa was waiting in the dressing-room, nervous as her dress was late. Another *Vogue* photographer and friend of Lisa's, Frances McLaughlin Gill, remembers her saying: 'I've never met Mr Penn.' Frannie said: 'Oh, he's a very nice young man, I'll introduce you.' Frannie brought him back into the dressing room, but between Irving's preoccupation with setting up a shot with twelve models, and Lisa's worrying about the arrival of her dress (as was often the case in those days, designers guarded their designs ferociously before showings; a new dress was treated like a state secret), their meeting seemed uneventful, but according to Irving it was love at first sight. They were married three years later, and the work they did together for *Vogue* in 1950 of the Paris collections has entered our subconscious as synonymous

OPPOSITE: PHOTOGRAPH IN THE STYLE OF ANDRÉ DURST, MID-1930s, COLLECTION LISA FONSSAGRIVES

with glamour. But they are more than fashion photographs, much more. They have the monumentality of Nadar, and the searing, indelible quality of August Sander. They are masterpieces of the genre. It is hard now to understand the radical departure from the norm that they represented at the time. They are devoid of any accessory, stripped and served up like religious icons. Lisa said she radiated energy into the lens until she felt the photographer had the picture, and indeed, there is something other-worldly about these images. There was a kind of conspiracy going on; they were collaborators in smuggling art onto the printed page. Lisa almost seems to be mocking us, smirking, naughty, snobbish, engaging, irresistible. We see her frolicking in magical innocence.

In my estimation, there are two images that define the postwar zeitgeist: Richard Avedon's Dovima with the elephants and Lisa in the Rochas mermaid dress by Penn. The combination of Penn's talent and the complexity of Lisa's character, filtered through their symbiotic vision, provide us with quintessential photographs depicting the mannered theatricality of the eighteenth century mixed with the streamlined aerodynamism of a new era. Lisa *was* fashion, yet ironically the antithesis of it as attested by her inordinately long career. Her beauty was of a more eternal nature, transcending the rapid metamorphoses of trends – and at once, paradoxically, the perfect embodiment of every change. She had a remarkable sense of serenity and a civility comprised of a combination of boldness and reserve. She believed her soul to be pagan, but her exterior was genteel. Not a hint of conflict on that angelic face. Always relaxed but with great inner energy; a mysterious blending of the graceful and the formidable. She was as beautiful for what she wasn't as for what she was. She was never threatening, but balanced. She was neither too perfect, nor too sensual, nor too cold. This was the stuff of movie stars – Marilyn, Liz, Garbo, who presented to the world an impossible, unattainable dream, a fairy tale or an unspeakable tragedy just beyond the grasp of every woman. Lisa's glamour, or at least a version of it, seemed to be accessible to every woman. She projected an energy that resonated in the subconscious of generations of women to whom her appeal was irresistible. Hers was a quiet beauty, indifferent, splendid in its childlike naïveté. She never seemed to be trying to sell anything; she didn't have to convince you because she was always true to herself. Her dance experience gave her a sense of theatre so that the elaborate costume never looked mannered or affected – a comfortable masquerade.

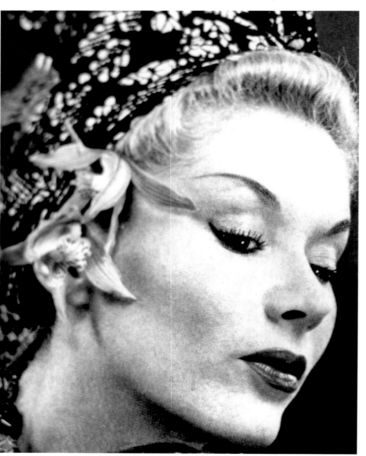

DETAIL OF VOGUE COVER BY ANTON BRUEHL, 15 JANUARY 1940

Little about photography is true of course, except that it serves up artifice and fantasy as truth. In these half-truths, we can only hope to ascertain glimpses of reality, reflections of a troubled or ideal world. Lisa maintained a kind of Zen detachment from all the false importance of the fashionable. She was pure and good and marvellously old-

fashioned. She felt progress had done little more than deprive one of the stoicism necessary for spiritual development. I came to her young, excited and starry-eyed, full of enthusiasm for what I thought had been an exquisitely beautiful, idyllic time in the world. She said: 'Are you crazy? There were the McCarthy hearings! The undergarments were incredibly uncomfortable. The shoes were so heavy and ugly and impossible to walk in. And those mandatory white gloves! They got dirty the second you put them on. One sitting I'll never forget: I had very hot spotlights on either side of my face and was wearing gold button earrings. The metal conducted the heat from the lights and blistered my ear-lobes. It was not one big party.' But it looks like one big party, like a fabulous celebration, and therein lies Lisa's unique talent and wonderful gift to us all. In an impossible world, she made everything seem effortless. One can't help marvel, though, at such a gullible public. Fashion copy gushes – not a trace of irony – post-Hiroshima – cars get bigger and bigger, horrible puritanism, nice girls dance at arm's length. No hint of pollution or overpopulation. No memory of wartime atrocities or ever any plague. Life in a blissful vacuum where the be all and end all is to come up with a new colour of 'mutation mink'. *Vogue* reduces old masters to 'Elegance in Art', talking about Chardin's stiffened ribbons. People don't go to the bathroom, they don't have nervous breakdowns, there is no alcoholism; it is a hermetically sealed world of ice cubes clinking in

PORTRAIT. PHOTOGRAPH BY DAVID SEIDNER, 1990

tumblers and salted nuts in silver trays. In addition to the editorial photographs, Lisa is ever-present in two decades of effortless advertisements for everything from perfume to hair dye to every major department store, and for a multitude of Seventh Avenue fashion houses and fabric manufacturers.

Lisa was aware of the calibre of people she worked with, and she began, in the 1930s, to return to magazines and photographers to ask for prints. She collected over two hundred and fifty vintage prints, some, like the Platt Lynes, extremely rare (he destroyed most of his fashion archives, considering them to be inferior to his more 'serious' work). This book was a natural idea, and I was told by Gene Fenn, a photographer who was George Huene's assistant, that Huene had always told Lisa to do a book one day. She never mentioned this to me but when I proposed the book to her and Lothar Schirmer, the publisher, they were both delighted. We began the project in 1988, with Diana Edkins as project co-ordinator, thinking it would take two years; in 1992, with the book two years late, Lisa passed away. I'm deeply sorry she will never see this labour of love and this remarkable monument to her timeless beauty, grace and dignity.

In the summer of 1990, Lisa and I decided to do a sitting together. She and Irving were staying at the Hotel Crillon in Paris while he was photographing the haute couture collections for American *Vogue*. I arrived some time in the late morning to find Lisa in a standard double room (not a suite, never anything

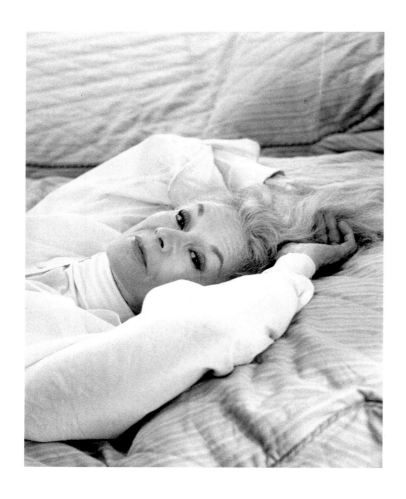

grand). She was dressed from head to toe in simple white cotton. I had never photographed her before with the exception of snapshots and was completely unprepared for the transformation about to unfold before my eyes. When the lights came on and the camera was in place, my friend L.F.P. became L.F.P. the model, that exquisite creature I had only known from photographs. I was dumbstruck and thrilled. 'Lisa Fonssagrives', that magical, musical name conjuring countless images reappearing through my lens. The chin jutted, the face leaned forward almost as if it were coming out of itself, and with a deft tilt of the head in the light, and the movement of the hands, she moulded herself into that familiar vision of perfection. A few almost imperceptible movements here and there, and suddenly, the doe eye, the cheekbones, the curve of the upper lip, all in place, all flawless, and I was transported to 1936. I had never seen such a keen, innate awareness of one's sense of self-representation through light and movement. At seventy-eight years old, Lisa was tireless, practically doing gymnastics in

HÔTEL CRILLON, PARIS 1990. PHOTOGRAPHS BY DAVID SEIDNER

certain poses. When she saw the contacts, she sent mea beautiful note, saying she loved the pictures, impressed by my choices of light and composition, never once mentioning the way she looked. That was Lisa, selfless and without vanity, and always with the intelligence of detachment so important to any kind of critical faculty.

In August 1990, she wrote to me about the publisher: 'Please don't put pressure on him. I have repeatedly asked you not to do that. I feel he must take his own time – it is so important to do a work of fine quality in this book, we have such a great responsibility towards all these photographers whose works we are using. Once Lothar said: "This will be a little jewel". That made me very happy. Let's keep that in mind and hope for it … Now is the best time of the year in Paris, so have a wonderful life and believe in the future … Just now an enormous flock of Canadian geese came over the house – an awesome sight – maybe I'll be one of them some day, who knows …

Très tendrement, your friend L.'

LISA FONSSAGRIVES-PENN
MARTIN HARRISON

It is the fall of 1950, at precisely the mid-point of the twentieth century. The latest issue of *Vogue* arrives as usual at the homes of thousands of subscribers. More copies reach buyers at shops and news-stands. I have often tried to imagine the reaction of readers as they thumbed through the pages. Reaching page one-hundred-and-something they were confronted with Irving Penn's reportage of the Paris collections. Did they not feel that here was something different, something special? Surely the shock of these intense, riveting photographs provoked a surge of excitement in even the most casual reader.

That Penn was able to sustain their impact throughout the whole series was a remarkable achievement – and indeed the photographs of Lisa Fonssagrives, wearing the designs of Rochas, Balenciaga, and Lafaurie, have become timeless classics of the medium. We can only speculate about how they were first received over forty years ago, but the critically unanimous judgment of history is that they remain unsurpassed examples of the genre. Yet these celebrated photographs, which were a high-point for both photographer and model, also represent a watershed, not only in the evolution of fashion and its photography, but also in the life and career of Lisa Fonssagrives.

On the part of both Penn and Lisa the unparalleled dignity of the Paris series was the result of a considerable maturity and dedication. It is salutary to compare them with the ephemeral images of teenage icons which are their present-day counterparts. And it should be remembered – this comes as a shock to anyone who has not considered it – that Lisa was thirty-nine years of age when these historic photographs were made. She had been a photographic model for fourteen years, and had already begun to devote less of her time to the profession. Immediately after leaving Paris, Lisa and Penn were married, and when her second child was born two years later her withdrawal from modelling, at least on anything like a full-time basis, was complete.

Lisa Fonssagrives-Penn had at least five careers – dancer, model, photographer, fashion designer and

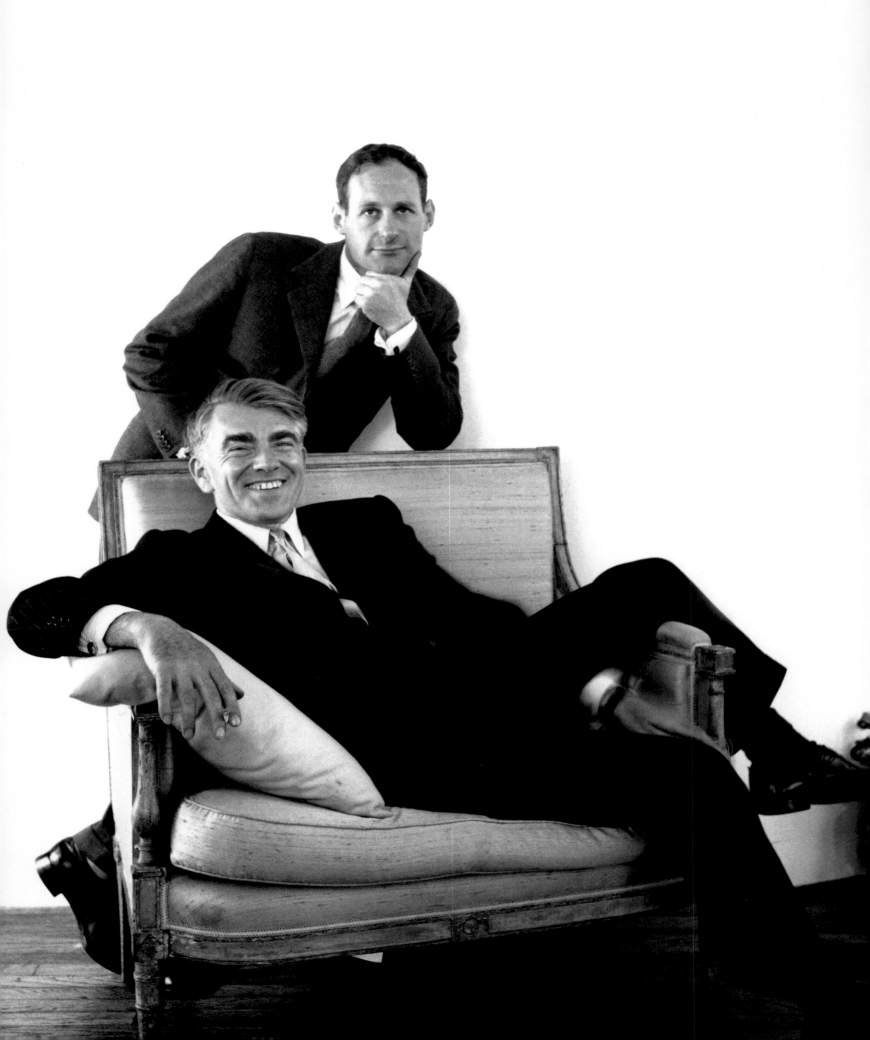

sculptor. But it is her role as model and muse to some of this century's greatest photographers, in Paris from 1936 to 1939 and in New York from 1939 to 1952, which is at the heart of this book.

Lisa's career as a model was uniquely informed by her training and early professional life, experiences which placed her at the centre of contemporary cultural developments. When her first husband, Fernand Fonssagrives, began to photograph Lisa in 1934 it was in the leaping, super-athletic stances that characterized an important aspect of the avant-garde. The cult of the dynamic body appropriated by fashion photography in the 1930s was founded on an amalgam of diverse cultural references, from Diaghilev and Futurism to the post-war rehabilitation of Germany and the *Neue Sachlichkeit*. Women were portrayed in magazines as symbols of the urgent pace of change in modern urban life; movement, speed and modernity were assumed to be synonymous. Lisa's inherent grace and athleticism, intensified by her training as a dancer, were attributes which Fonssagrives was able to exploit in syndicating photographs of her to the many European magazines which specifically catered to the new passion for health, action and beauty.

Her first sittings as a fashion photographer's model though, in Paris in 1936, were not outdoors in the sunlight but in the studios of *Vogue* and *Harper's Bazaar*. The long exposure times involved were a technical imperative, and, paradoxically, her feeling for movement had to be reined in to some extent – implied rather than directly expressed. It was a restriction which extended to the majority of the sittings in which she participated, and although there were exceptions – her work with Munkacsi and Frances McLaughlin-Gill for example – it clearly obtained in many of her greatest collaborations, with Penn, Horst and Hoyningen-Huene. The very considerable contribution she succeeded in making within this discipline is one of the aspects to emerge from this study; it is also fundamental to the debate about fashion photography's continuing shifts

between the polarities of the formal and informal, between the static and the active body.

Unlike today, during the twenty-year span of Lisa Fonssagrives-Penn's career the balance of power was vested in the photographers of fashion, rather than their models. Similarly it is the photographer who has been pre-eminent in recent re-assessments of the history of fashion photography. Yet the contribution of the model has been crucial in this essentially collaborative endeavour, and it is ultimately their, and not the photographer's, image which speaks directly from the page to the viewer. Curiously it is an aspect of fashion photography that has received little attention, even, so far, from a new generation of feminist writers and cultural historians. And although several models have written about their experiences, they have generally failed to investigate their roles in any depth, favouring either straightforward autobiography or passing on 'beauty hints'.

The female model in women's fashion magazines occupies, in one respect, a novel position. It has become a commonplace of art history that, since the Renaissance, paintings have generally been made by men, of women, for men to buy and look at. The fashion photograph in the twentieth century turns that idea around – images of women are made to be looked at not by men but by other women. It would be unrealistic, of course, to claim that women's fashion magazines were created primarily out of altruistic or feminist ideals – the straightforward commercial logic behind the phenomenon was that a new consumer group had been identified. The hierarchy of these magazines is organized along these lines: owners/publishers, and art directors, are generally men; editors-in-chief and fashion editors women; photographers both men and women; models (apart from the occasional subsidiary token-male) are women. But to suggest that these magazines do nothing more than promote buying by encouraging insecurity is simplistic at best. Irving Penn declared, 'I always felt I was selling dreams, not clothes': since only a small proportion of the

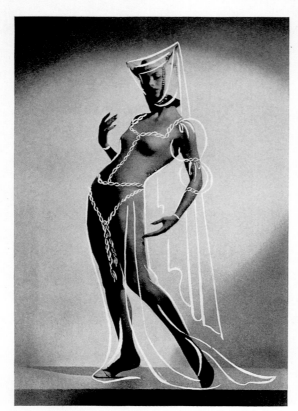

Mediæval: This fine fourteenth-century (or Iron Maiden) attitude, pelvis forward, looks well on tapestries; not so good anywhere else

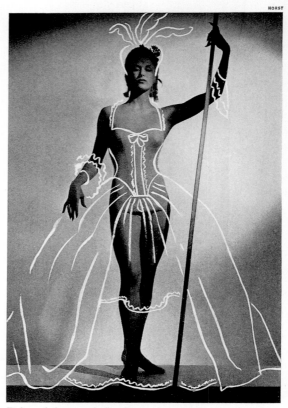

Eighteenth-Century: Stiff with brocade, encumbered by hoop-skirts, rigid of spine, these ladies walked (not ran) through the minuet

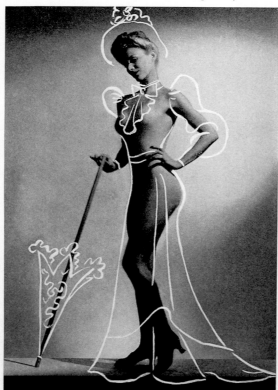

Gay 'Nineties: This elegant sway-backed stance made bustles and padding almost unnecessary. The technical name for it is lordosis

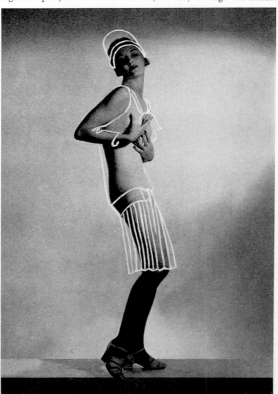

Flapper: The chic "Débutante Slouch" of the 'Twenties involved a drooping spinal column, a concave chest, and an air of disillusion

'OUTLINES OF HISTORY.' PHOTOGRAPHS BY HORST, VOGUE, JANUARY 1952

mass readership could presumably afford the clothes illustrated in the high fashion glossies, it is reasonable to conclude that they were willing participants in an acknowledged fantasy activity.

In 1953 the photographer Saul Leiter was walking along Fifth Avenue in New York. He stopped briefly to look at the display of a large store, and as he did so the sun pierced the overcast sky. Peering into the window he was aware of the reflection of a woman standing behind him, the light glancing across her features. 'Very occasionally', he recalls, 'one's fantasy becomes reality. She measured up to her image of grace and beauty in the way very few people ever do.' The woman in question was Lisa Fonssagrives. Though they did not speak, and it was the only occasion on which Leiter ever saw her, even this fleeting glimpse was a closer acquaintance than most people share with the objects of their dreams. The dream of the woman reader of a fashion magazine would presumably involve the replacement of the self-referential model with an idealized image of herself, perhaps wearing the same garment. These magazines are not targeted at men, though they seem to have attracted some (limited) male attention. The writer Glenn O'Brien embraces fashion photography as 'pornography for connoisseurs', and an article on Lisa in *Time* in 1949 (she was the cover feature, the first model to be accorded this treatment) referred to the fan-mail she received and her unlooked-for popularity as a pin-up girl.

One of a very few women who transcended the customary anonymity of photographers' models at that time, Lisa Fonssagrives's face was known to millions through countless magazine images. But she was reserved in private and remained little-known as an individual outside her family and a small circle of friends. Her intimates all testify to her warmth and humour, but point out that she seemed uncomfortable if she felt under scrutiny at social gatherings, a shyness that was sometimes mistaken for remoteness. Alexander Liberman says: 'There was a *gravitas* about her that imposed admiration and respect.' It may also be that a lack of physical inhibition, combined with psychological introspection, are immutable characteristics of the Nordic temperament. Several people likened Lisa for this reason to her compatriots Greta Garbo and Ingrid Bergman, and as she herself recognized, 'Swedes, you know, are very introspective people – it's those long, dark winters.' She created around her an unpretentious lifestyle which afforded ample opportunity for communing with the elements ('All Swedes are nature lovers') and was adept at balancing her career with her personal life: 'Modelling always seemed, in a sense, very artificial, and my family was always the core of my existence.'

Time quoted her as stating with more than a hint of resignation: 'The photographer says "Look sexy" and I look sexy. He says "Look like a kitten", and I look like a kitten. It is always the dress, it is never, never the girl.' She mockingly described herself as 'just a good clothes hanger', though this belies how much she invested in photographic sittings, her sense of responsibility, and endless generosity. Especially touching is the testimony of several less-than-renowned photographers, who readily acknowledged their indebtedness to her, who understood what she had brought to a successful photograph.

The top models of the 1990s tend to be homogenized facial and bodily types, highly paid and cosseted. Even if they were willing, they would be barred, for insurance reasons, from taking the kind of physical risks which were bread-and-butter to Lisa. Neither would they readily suffer the discomfort of lengthy sittings under hot spotlights: more than once under these conditions Lisa fainted with the heat, only to be administered smelling salts and expected to carry on. The adaptability of Lisa's physique was amazing, and enabled her to switch easily from litheness to poses of tranquil elegance. She was always responsible for her own hair and make-up, and placed great emphasis on the utilization of these skills in increasing her range and variety, in assuming the character required of her.

Like many women who grow up to be considered beautiful, Lisa was insecure about her appearance as a child: 'I had two sisters younger than me, and I was the one who was gangly, skinny, ugly and shy – I never seemed to grow up to be a girl.' She could also be self-deprecating about her professional role:

'There was always something very difficult about being a model; people always had the attitude that if you are beautiful you must be dumb. You can only try your hardest – you can't surpass yourself – but I would like to feel that in spite of being this dummy I have a little something.' Nobody disagreed that Lisa had more than a little something, but naturally not all of the leading photographers could have found her particular qualities inspirational. Neither her naturalness nor suppleness are likely to have been assets which were at a premium in the static rococo fantasies created by Cecil Beaton, whom Lisa recalled posing for on one only occasion: 'Everything was swathed in yards of tulle; I had to clutch a large bouquet of red roses and I remember every thorn seemed to go into my body. I really wasn't his type.' Similarly, when Lisa began to work with Richard Avedon, around 1948, he had recently discovered Elise Daniels, a young model whom he credited as the catalyst for an important development in his photography; but her expression of vulnerability would have looked affected on a more mature woman, and it is not surprising that Lisa's collaboration with Avedon was limited.

The idea to make a book about Lisa Fonssagrives originated with David Seidner, a successful young fashion photographer. An enthusiastic historian of the genre, he was not even born when Lisa had virtually retired from modelling. But he had always been fascinated by this great model of an earlier era, and in 1984 arranged to interview her for the art magazine *BOMB*; at this meeting he suggested to Lisa that she should make a book. My involvement with the project began in 1991. We could not know it then, but Lisa did not have long to live: the last day we spent together was in December 1991, and just two months later she was dead. What was to be a co-operative celebration of a distinguished career instead became more a fond memorial.

We had covered a lot of ground together, and Lisa was the perfect interviewee – she dodged none of my questions and had excellent recall. Furthermore, she had kept a fine collection of original photographs, from which most of the plates in this book have been made. But there were gaps, and in the case of photographers no longer living one is faced with a problem familiar to anyone who has tried to research the history of fashion photography. Nothing is perhaps more indicative of its status than the loss of crucial archival material. Vast numbers of key works have been destroyed or lost, and even most of the magazines in which they were reproduced have become extremely scarce. Fortunately for this volume Penn and Horst are two photographers who have held on to substantial archives, but the omission of some lesser-known names is an indication of the lack of available material, rather than a reflection of their merits.

Lisa Bernstone was born in 1911 at Uddevalla, a small town in Göteborg and Bohus province, by the west coast of Sweden. Popularized as a resort by Prince Wilhelm, it is an area of fjords, islands and fishing villages next to the Skagerrak, with lakes and forests inland. It provided the backdrop for an upbringing that was both comfortable and happy. Both of Lisa's parents were doctors, though her father was also an enthusiastic amateur painter, and her mother was actively involved in designing and making clothes and artefacts for the house and family. The Bernstones all shared a keen interest in the arts: 'our travels through Europe always revolved around Museums, and were one of the most important parts of my education.'

Lisa grew up close to nature – even in Sweden it was considered daring that the Bernstones preferred to swim in the nude – and in an atmosphere that encouraged both creativity and an active, outdoor lifestyle. In a sense part of her never left Sweden, and although she lived in the United States for fifty-two years she never lost the Swedish accent in which she confided to me 'Europe is still home – and if they cancelled all the planes…' She spoke to David Seidner about her abiding 'tenderness and love for everything in nature… I find myself very happy going out into nature and being absorbed by the universe. Maybe it takes the place of meditation. The idea that God is nature.' What people mostly seem to remember about a splendid party thrown by the Penns in the 1970s is the white doves, which Lisa had dyed green and pink specially for the occasion.

This temporary embellishment of bird-life harked back to her childhood, when she would make dresses and bonnets for the Bernstones' chickens and pull them around the garden in a little wooden cart. Penn recalled the credit he received for a *Life* cover 'which was basically a beautiful arrangement of grasses by Lisa, in the same way she would collect them from the farm and arrange them for our house.'

In spite of providing an apparently idyllic environment, her parents had no desire for Lisa to pursue a career, and planned for her to attend a finishing school 'so that I was prepared to become a housewife'. But Lisa's ambition had always been to become a choreographer, and in 1930 she left for a school in Stockholm where, besides art and design, she was able to study dance. In 1931 she moved to Berlin, where she studied choreography with the most important of her teachers, Mary Wigman. At the end of the First World War the German people were actively encouraged to take up dance as a means of physical rehabilitation after wartime undernourishment. This initiative in turn fostered an intense interest in dance as an expressive art. Mary Wigman herself had studied at the experimental Dalcroze Institute and under Rudolf von Laban, a leading theorist in the psychology of movement and the analysis of space. In her new understanding of the body in architectural space Wigman was a major contributor to the evolution of dance in the generation following Isadora Duncan, and it was this which she passed on to Lisa, who acknowledged 'she was the first to make me conscious of space.'

Returning to Stockholm, Lisa opened her own dance school. One of Stockholm's most celebrated choreographers at that time was Astrid Malmborg, and in 1933 she invited Lisa to participate in an international competition in Paris, in a ballet set to music by George Gershwin. 'We travelled by boat down to Paris, and I was so excited I danced on deck all the way. We didn't win first prize, which went to the Ballet George, though we did get some kind of honourable mention; but I fell in love with Paris and decided to stay there.' In Paris, Lisa studied art history at the Sorbonne, and enrolled in a classical dance course – as opposed to the modern variety she had hitherto studied exclusively – directed by the Russian Princess Egorova. Not long after her arrival she met a Frenchman and a fellow dancer, Fernand Fonssagrives, whom she married in 1934.

Fernand Fonssagrives had emigrated with his family to the USA in 1928, and subsequently divided his time between there and Europe. He and Lisa worked together as dancing instructors but his career as a dancer was cut short when he badly injured his leg in a diving accident. To help him pass the time while he recuperated Lisa gave him a Rolleiflex: 'It was my first serious camera,' said Fonssagrives 'and it became part of my body.' He began to photograph Lisa, and showed his pictures to magazine editors. They met with immediate success and the couple set out to tour Europe, working their way as an itinerant photographer and model team. 'Fernand was charming, great fun – we were like children in those years, recalled Lisa, 'there was dancing, the excitement of new ski-jumps, swimming – *play* really, which would become part of being a model.'

In their Hansel and Gretel-like existence they camped out under the open skies and at one point constructed a beach-house on Noirmoutier, an island off the Atlantic coast of France, all the time moving like gypsies from place to place, selling photographs to magazines as they went. These photographs – of Lisa diving, leaping or bathing – reflected her natural spirit but also found a ready market in the burgeoning magazines catering to the Modernist fascination with the energized body moving through space, with health, sports and glamour. When in Paris the Fonssagrives continued to give private dancing lessons in people's homes; returning one day to their tenth-floor apartment they met a man in the elevator who explained that he was a photographer and asked if Lisa would model some hats for him. Surprised, but mildly flattered, she agreed. The photographer was Willy Maywald; when Fonssagrives saw the photographs he decided to show them to Madame Dilé, manager of the Paris *Vogue* studios. Madame Dilé was suitably impressed, and spoke to one of *Vogue*'s leading photographers, Horst P. Horst, who arranged to make some test pictures with Lisa. The phenomenon of the model

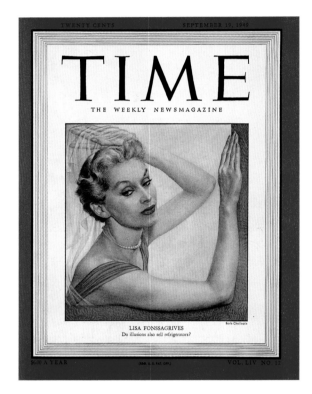

LISA FONSSAGRIVES, FIRST MODEL TO GET A COVER
STORY IN TIME MAGAZINE, 19 SEPTEMBER 1949

agency did not yet exist in Paris in 1936, but the next stage of Lisa's career, when she 'sort of became a model', was about to begin.

'On the day of that first test with Horst I was terrified. I knew nothing about fashion, and had never even looked at a fashion magazine. I had no idea what was expected of me; I didn't know what to do with my hands, or how to pose. Horst was very kind to me, but in 1936, nearly as inexperienced as I was. I remember I wore a dark brown wool suit which I had made myself. My hair was all over the place – long and completely unmanageable – no one knew what to do with my hair.' Horst, too, remembered how she had 'trembled with fear'; in spite of this he must have recognized her potential, for the neophyte model was immediately booked for a *Vogue* sitting, modelling dresses by Alix and Lelong. Lisa soon demonstrated that if she was going to become a model she would take the business seriously. 'I went straight to the Louvre and began to study how painters of all periods had posed their models. On a sitting I would examine the cut of the dress carefully and then practice different poses to see how it fell best. Sometimes a certain pose was wrong for the type of lighting being used, so I would rehearse the way it should look in a mirror.' She asked for extra sets of the contact sheets from each of her sessions, poring over them to see where there was room for improvement. 'I made my own critique of the contacts in a completely detached way. I think it helped that I was able to be objective – it was like looking at photographs of "this girl", not Lisa Fonssagrives; I would say to myself "Here this girl looks right – there she is posing awkwardly."'

Lisa's training as a dancer was invaluable. 'Since I was a child I have always danced in daily life. And my training as a dancer gave me tremendous control – I could stand on one foot forever. In a photograph I was really performing a "still dance"; the photographers would often direct you of course, but the movements I suggested were basically arrested dance movements.'

Horst had been a photographer at the Paris studios of *Vogue* since 1931, where he was a protégé of his friend, George Hoyningen-Huene. Following a row with their art director, Dr Agha, the temperamental Huene had left *Vogue* in 1935 and transferred his services to their chief rivals *Harper's Bazaar*. Cecil Beaton was an occasional visitor, but this had effectively left Horst in the position of *Vogue*'s chief photographer in Paris. Lisa, therefore, was beginning this new phase of her career at the top of the ladder. Horst often referred to her as his favourite model, and certainly she features in some of his most renowned photographs. Nevertheless the special qualities she was able to bring to a sitting ('seance' was Lisa's favourite word) might, on the face of it, seem more appropriate in the context of an outdoor, action-realist photographer such as Martin Munkacsi.

Although Toni Frissell had, in New York, begun to break through Condé Nast's dogged resistance to roll-film cameras, the studio view camera (usually 8 x 10 in.) remained the rule for *Vogue*'s most important fashion coverage. The slow speed of black and white films necessitated exposure times which averaged one or two seconds, clearly precluding any kind of 'arrested action' photograph. In 1936, Horst was at the height of his interest in placing his models in an elaborate studio 'set', frequently designed especially for the sitting by one of his friends, such as the interior decorators Jean-Michel Frank or Emilio Terry. He recalled that the Paris studio was equipped with about twenty large floodlights and spotlights: 'I felt that if I were to use floodlights only, the result would be an even, all-over in-focus, but *flat* picture. I preferred to use the spotlights, to emphasize the important points of a dress ... To show a face at its best and most attractive, I tried lighting from below or from the side, or sometimes straight on with just the eyes or cheek lit up.' Lisa called Horst 'an expert with lights. But the heat from over five kilowatts of lighting could be overpowering – I always remember the studio floor littered with the "snakes", the cables for all the spotlights; he was very considerate though, and didn't bring me onto the set until everything was ready.'

Horst gradually simplified his approach, and eliminated the props, and some of his most compelling photographs of Lisa rely on very little other than his mastery of studio lighting and the

graphic power of his compositions. Since no actual physical motion was possible in his photographs, the idea of movement Lisa was able to convey in her expression and the position of her limbs was a key factor in the internal dynamics of the photograph. She was also the inspiration for some of his most successful nudes: 'One day I wanted to make some nude photographs, which I had never done before. She had a very beautiful body, and was not afraid of her body – she was used to *Nacktkultur*.' Of the multiple-exposure of Lisa with the harps, Horst added: 'I tried to make the photograph look romantic, of course – to make some theatrical effect. The man who was editor of *Town and Country* called me up outraged. He was convinced it was his wife. It was not, it was Lisa.'

Lisa was soon in demand from most of the fashion photographers working in Paris. Models were not, at this stage, discouraged from posing for both *Vogue* and *Harper's Bazaar*, and so she was free to work with George Hoyningen-Huene. 'A seance with Horst was always fun, but Huene was the exact opposite – he insisted on complete silence in the studio, rarely smiled, and was very serious. But he was always kind. Because of the heat problem he carefully arranged the lighting on a stand-in, and he was extremely well organized and knew exactly what he wanted.' Huene would doubtless have respected the fact that Lisa's professionalism matched his own, for not all of his models seem to have been regarded so highly. According to fashion editor Bettina Ballard, Huene was 'the most difficult star. He would walk into a sitting late, take one withering look at the models standing nervously in the dresses he was to photograph, turn to the editor in charge, and say "Is this what you expect me to photograph?" snap the camera a few times, and walk away.'

By 1937, when he first photographed Lisa, Huene was based in New York, generally visiting Paris only to photograph the 'collections' for *Harper' Bazaar*. He left a description of the tense, frenetic atmosphere, sessions beginning at midnight and continuing through the small hours of the morning, the rush to process negatives, make prints, retouch them, and the dash to get them on the boat for New York. Regarding models, Huene preferred those who 'had little experience, as other photographers would often get them in bad habits, making them use artificial and unnatural poses. What I tried to make them do was to be free and relaxed, natural, the body poised with ease and grace. Above all, the movement of the body must be in keeping with the dress but not conscious of it. This sounds contradictory but isn't. An elegant woman gets the feel of her dress and then forgets all about it and moves in the style of the dress automatically.'

His *Lisa in the Vionnet Evening Dress* (1938) epitomizes qualities he describes having sought in a photograph. One of the most convincing expositions of 1930s neo-classicism in fashion photography, it was described by Penn as 'one of very few photographs where I found myself saying "I wish I had taken that."' It crystallizes Huene's eclectic cultural background – the displaced Russian aristocrat who trained in Paris with Cubist painter André Lhote and turned Modernist. Inspired by David's *Madame Recamier*, it eschews even the minimal props the artist had introduced in the original. Huene rarely used studio backgrounds of the same complexity as Horst's or Beaton's, preferring to use merely a hint of a simplified form of classical column to surreal or rococo effects. By the late 1930s he had almost entirely banished even such vestigial hints of theatricality, and his more direct and radically pared-down style – *Lisa in the Molyneux Hat* is a fine example – anticipated 'innovations' of the post-war period.

Even though fashion magazines were generally published monthly, the most important photographic activity in Paris was concentrated around the spring and autumn collections, and Lisa was still able to leave the city at other times to continue her European wanderings with Fernand.

Another New York photographer sent by *Harper's Bazaar* to Paris specifically to cover the collections was George Platt Lynes. Lynes had first visited Paris in 1925 and he could, like Huene, cite Man Ray as his original inspiration in photography. One of Lynes's earliest photographs of Lisa, wearing an unusually romantic dress by Alix from the spring 1937 collections, typifies his relaxed, dream-like

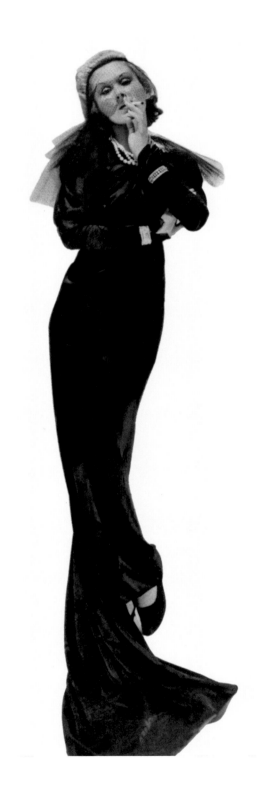

FASHION BY MAINBOCHER, PARIS 1937. PHOTOGRAPH BY GEORGE HOYNINGEN-HUENE, HARPER'S BAZAAR, SEPTEMBER 1937

style; he almost invariably built his sets on the kind of raised platform used in this example, imparting a hieratic quality, a quiet dignity. Man Ray himself was still living in Paris, though he had done almost no fashion photography since his pioneering contributions to French *Vogue* in 1925–26. When Alexey Brodovitch became art director of *Harper's Bazaar* in New York in 1934, one of his first achievements was to persuade Man Ray back into the fold as a fashion photographer. But Man Ray was equivocal about his involvement in commercial photography, and sometimes his fashion was merely routine, with less of the experimental inventiveness for which he was justly renowned in other areas. His photograph of Lisa in the lobster dress, for example, was attractive enough but quite conventional, although the macabre set of teeth he had Lisa wear in his depiction of a 'sinful' Mainbocher dress introduced a note of camp/surrealist drama. Willis Hartshorn noted that 'Man Ray's models never look out longingly or defiantly at the viewer: in fact…they are denied expression completely.' Hartshorn's claim that Man Ray's method of directing his models allowed them little scope to contribute anything of their own is borne out by Lisa's comment on the 'lobster dress' photograph: 'Man Ray made me do that pose – in fact he would

FASHION BY ELSA SCHIAPARELLI. PHOTOGRAPH BY MAN RAY, HARPER'S BAZAAR, APRIL 1937

never let me suggest poses at all. He seemed very disconnected with me that day – very severe – though he wasn't always like that.'

Man Ray never painted surrealist settings for his fashion photographs, although Lisa appears in a striking *Harper's Bazaar* spread (15 September 1937) in which he used Giacometti's *Albatross* sculpture as a backdrop to three Chanel dresses. The Paris photographer who most conspicuously employed, if only briefly, surrealistic spatial effects was *Vogue*'s André Durst. His short career began in 1933 and was effectively ended by the occupation of Paris in 1940; all of his negatives are thought to have been lost in the war and his work is exceedingly scarce today. But he was considered, in the late 1930s, second only to Horst of French *Vogue*'s photographers, and it is regrettable that his work is not better known. Cecil Beaton's sardonic dismissal of him – 'The importation of a field of corn to the studio was his swan-song and Durst became dust' – referred no doubt to a 1939 photograph for which Lisa modelled and which is in fact a fine example of Durst's gentle, elegant style.

Durst's ultra-sharp view camera images were rendered in rich and subtle tonalities, which were further enhanced by *Vogue*'s high quality black and white half-tone reproduction. His photographs still

clung to the aristocratic connections that had been professional fashion photography's aspiration since it began with Baron de Meyer in 1914. But this withering tradition had been challenged in 1933 when Martin Munkacsi, a Hungarian sport and reportage photographer, photographed a model *running* for *Harper's Bazaar*. Thereafter fashion photography continued to fluctuate between the active and the static, the spontaneous and the monumental body, between the formal and the informal, the studio and outdoors. The dynamic body-in-motion was associated with moving film, photojournalistic 'realism', with freedom and modernity; dress codes themselves were becoming more relaxed as a result of the eruption of sportswear styles in the 1920s. Magazines looking to increase their circulation were forced to take account of this cautious democratization of fashion by appealing to its widening market. Possibly even more significant in content than his first 'action' picture was Munkacsi's photograph of a woman leaving an A&P chain-store with her groceries; here the everyday invaded the territory of leisure in an image which, as Carmel Snow openly acknowledged, was aimed to 'bring in the suburbanite who more and more represented our reading public.'

Condé Nast's urgent response to Munkacsi's innovations on *Harper's Bazaar* was to lift his embargo on roll-film cameras and let loose Toni

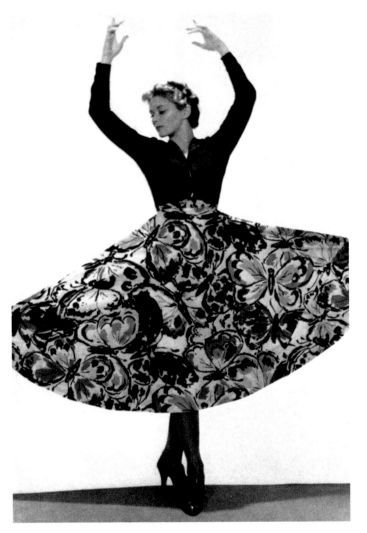

FASHION BY MAINBOCHER. PHOTOGRAPH BY MAN RAY, HARPER'S BAZAAR, 15 SEPTEMBER 1937

Frissell's 'snapshot realism' onto fashion. Nast was gradually won over by the new approach, but to dispel any lingering doubts he took the unusual step of asking *Vogue*'s readers their preference. The 15 June 1941 issue of American *Vogue* invited readers to cast their vote in favour of either a Horst studio photograph or a Frissell outdoor one. The same two dresses were used in each example, and the comparison is interesting, though neither photograph was particularly distinguished. When more than three-quarters of those who responded favoured the Horst, Nast apparently decided he had framed the question incorrectly. This inconclusive episode at least underlines how seriously the issue was taken at the time, though ultimately both approaches have persisted. Carmel Snow seemed to be advocating a balance in *Harper's Bazaar*, casting the 'cool perfection' of Hoyningen-Huene as the perfect complement to Munkacsi's action pictures.

Lisa did not work with Munkacsi until she moved to New York, but she frequently modelled for his Paris counterpart on *Harper's Bazaar*, Jean Moral. Moral's photographs almost invariably showed a woman simply walking along a Paris street. Their realism was a useful adjunct to the *Bazaar*'s collections coverage, the most important of which was, until the advent of Richard Avedon, done in the studio; but Moral's contributions were clearly regarded as secondary, and were usually run small,

six or more to the page. Of the occasional exceptions to this rule Lisa figured in the most remarkable, a photograph of Schiaparelli's pyjamas for which Moral required her to parachute from the top of a very high exhibition tower. Never one to shirk a physical challenge, even Lisa was apprehensive about this, her first parachute jump: 'I don't mind admitting I was nervous as I stood up there, with the wind whistling around me. In the end they had to push me off the platform, and of course it was wonderful once I was in the air. I was quite happy to do this for Moral, though I got him to agree to just one take!' One of the most famous photographs of Lisa resulted from another risky sitting in Paris, for a new *Vogue* photographer, Erwin Blumenfeld. For his series *Portfolio de Paris*, published in French *Vogue* May 1939, he had Lisa clinging – one-handed but with apparent nonchalance – from the edge of the Eiffel Tower, high above Paris: 'For some reason this didn't worry me at all – I was young, strong and athletic. I returned to the Eiffel Tower in 1989, fifty years after the Blumenfeld sitting, and wanted to stand there again, but of course the whole area is fenced off now for safety reasons and I couldn't get anywhere near the spot.'

There was something of a daredevil streak in Lisa, and certainly a great love of speed. *Time* magazine reported in 1949 that, having become an amateur pilot, she considered any road-speed below 70 miles per hour dull. Irving Penn later recalled how, at the end of a working day, Lisa would rush home from Manhattan to their Long Island farm so she could spend the evening with their children; she drove her red Studebaker convertible at breakneck speed and was well known by all the local traffic cops, from whom she regularly collected speeding tickets.

One of her last sittings was with Lillian Bassman for *Harper's Bazaar* in 1961. The photograph was to be a double-page spread of a 'Golden Girl headed for summer in a gold Chevrolet Corvette'. Says Lillian Bassman, 'The idea was to show a woman driving a car, with the background blurred to suggest motion. My assistant was to drive our car at 50 m.p.h. with me hanging over the door with my Rolleiflex and the model driving alongside at the same speed. I asked Lisa "Are you a good driver" and she said she was. We went up to the Major Degan Highway, which was wide but very busy. Lisa wore a head-scarf. There was so much noise from the trucks that it was impossible to communicate, so if the scarf blew in a way I didn't like I had to indicate to Lisa with my hands. Still driving, she would re-tie the whole thing and arrange the bow – with no hands on the driving wheel. I couldn't believe my eyes. I don't know how she could do it, with all those huge trucks zooming by. I had no knowledge of her background as an athlete or her courage, it was just that she had the look I wanted for the picture, that long, beautiful neck. As soon as we had the photograph I was really glad to stop – I was in a sweat. I asked Lisa how she did it, but she was quite unconcerned, saying "Oh I used to be an aviator and so it was easy."'

In New York, Lisa would work with many of the women photographers, most frequently Louise Dahl-Wolfe, Toni Frissell and Frances McLaughlin-Gill. 'These were the three with whom I had the closest contact. With women photographers there is not the sexual polarization you feel with men – it is more like a sister relationship, and much easier to talk.' (In Paris though, with the single exception of model-turned-photographer Agneta Fischer, men still dominated fashion photography.) Dahl-Wolfe's arrival on the scene in New York in 1936 coincided with the advent of Kodachrome colour film, and her sensitivity as a colourist was a great asset for *Harper's Bazaar*. The ease of use of Kodachrome was an important factor in facilitating full-colour fashion photography, the growth of which was in turn largely responsible for the eventual demise of the fashion illustrators. Colour photography, however, remained the exception in Paris until much later, and here the illustrators retained their status. It is not perhaps widely realized that models sat for illustrators in exactly the same way as for photographers, and Lisa worked with many of the leading fashion artists of the time, including Cocteau, Vertes, Gruau, Erickson, Berard, and Richard Lindner.

In February 1939 Lisa travelled from Paris to *Vogue*'s London studio to model for John Rawlings,

who was photographing the London collections. Rawlings had been seconded to the London office by American *Vogue* in 1936. The most distinguished of *Vogue*'s English photographers, Cecil Beaton, was absent for much of the year in New York and Paris, and the plan was that Rawlings, who was finding it hard to break through in the competitive atmosphere in New York, could both gain in experience and help out with the perceived shortage of native talent. On at least one occasion, in Paris in 1937, Lisa posed for the under-rated English photographer Peter Rose-Pulham. Pulham, who was described by Beaton as 'a man of extreme originality', had recently moved to Paris, disappointed that London had 'paid such scant attention to his work.'

When the outbreak of war was imminent in 1939, Lisa and Fernand Fonssagrives were holidaying in Sweden. Instead of returning to Paris they decided to emigrate to New York. Fonssagrives quickly found regular work as a photographer for the magazine *Town and Country* and Lisa was soon able to re-establish contact with exiled European photographers such as Horst and Blumenfeld. They found a small apartment just above Blumenfeld's studio in the Gainsborough Building, on the south side of Central Park.

Modelling in New York was bigger business than in Paris and was organized on more professional lines. One of the first things Lisa did was to enrol with one of the leading model agencies, John Robert Powers. In addition to editorials she began to pose for advertisements, something she had never done in Paris. Although considered a less prestigious category of work, advertising paid a higher hourly rate. Initially she continued to work frequently with Horst. One of their most memorable collaborations was the 1940 cover of American *Vogue*, in which the magazine's title was spelled out by combining six images of Lisa's body (two for the letter 'O'), using her physical suppleness to striking effect. She worked occasionally with other *Vogue* photographers, Anton Bruehl and André de Dienes, but appeared much more regularly in the pages of *Harper's Bazaar*. Now she came up against the restriction which prevented faces too closely associated with one of the magazines being shown in its principal rival, and by 1941 was effectively banned from *Vogue*.

It was also in 1941 that Lisa gave birth to her first child, Mia Fonssagrives. She took her new responsibilities as a mother very seriously, and when she returned to modelling limited herself to working twenty hours a week, so she could devote the rest of her time to her family. Although she was New York's most highly paid model (in 1946 *Hold-It!* reported that she charged $40 per hour), the reduction in her income imposed a financial strain, especially since Fernand was more casual in pursuing his own career. At *Harper's Bazaar* Lisa became a favourite model of Louise Dahl-Wolfe, establishing a close relationship that continued well into the 1950s. 'I adored Louise,' said Lisa, 'but she was the greatest procrastinator I ever met. She started procrastinating at 9am. She was an uninterruptable talker, and all the time there was this second person inside her, working out how to do the picture. She adored her husband, Mike, but was childless, and I think she regarded all of her models as her children.' At *Harper's Bazaar* Lisa finally got to work with Munkacsi, and with him and Dahl-Wolfe was able to take part in the kind of *plein-air* sittings which related to the aerial leaps and outdoor naturalism of her early years in France.

It was not until 1947 that Lisa reappeared in the pages of *Vogue*, and even then the circumstances were exceptional, if fortuitous. The occasion was a gathering of the 'Twelve Most Photographed Models' of the previous year, and the photographer was Irving Penn. Ever since his first fashion photographs for *Vogue* in 1944 the embargo against *Harper's Bazaar* models had been in force, and so this was the first time he and Lisa had met: said Penn, 'I loved her when I first set eyes on her.'

Penn's progress at *Vogue* had been rapid, and he was quickly established as the magazine's most respected photographer. Art Director Alexander Liberman ensured that his work was accorded sympathetic layout and repro-duction: Penn became a regular, though not at first a prolific contributor, and his still lifes, portraits and fashion photographs ap-

peared as special events: the group photograph of the models was spread right across two pages and toned a cool, dark sepia, an extremely sensitive treat-ment of the tonal richness and dramatic chiaroscuro of Penn's original.

The intensity of feeling between Penn and Lisa was mutual, but had to be held in check, since Lisa was still married to Fernand Fonssagrives. Thus Penn and Lisa did not work together more regularly until some two years later. By this time Lisa was growing restless with shouldering the burden of greater responsibility in her mar-riage, and the break-up with Fernand was be-coming inevitable.

In 1949 Liberman sug-gested that Penn visit the Paris collections, not to take photographs but so-lely as an observer. This was part of the elaborate preparations for Penn's first coverage of the col-lections the following year, a reconnaissance that would acquaint him with the *modus operandi*, and the extra pressures of fashion's biggest annual event.

The careful planning bore fruit in Penn's first Paris reportage. This justly celebrated series was pub-lished in all three editions of *Vogue*, American, French and British. There were no duds, but it is no disrespect to the other models who took part, Bettina, Regine and Diane, to suggest the superiority of the photographs of Lisa Fonssagrives. Penn had had six years to refine his skills as a fashion photographer, but Lisa had enjoyed fourteen years at the top of the modelling profession. 'She taught me so much,' says Penn, 'and not just about fashion', and the results of this coming together of their experience and dedication

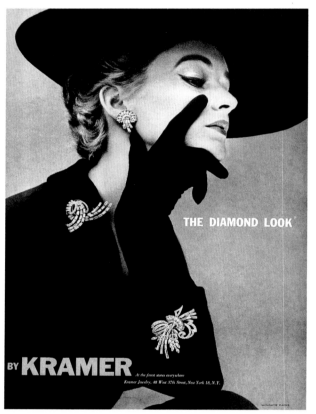

ADVERTISEMENT FOR KRAMER JEWELRY. PHOTOGRAPH BY WINGATE PAINE, 15 NOVEMBER 1951

were, as Penn says, 'more substan-tial than either of us'.

Penn has been unequi-vocal that in a fashion photograph, as opposed to a portrait, the personality of the sitter is of no relevance for him – she acts as a cipher rather than an individual. But in August 1950 he and Lisa were deeply in love, and it is not difficult to detect in the Paris photographs the most conspicuous exception to this rule. In fact every element of this series seemed to lock together perfectly. 'Part of Lisa's professionalism was never to put any strain on the pho-tographer. She was so supportive, so patient. I would give the most minu-tely specific instructions – "Move the muscle of the left calf", or "Turn that toe" – and she under-stood. She never pleaded tiredness – I was always the one who would "cry uncle" first. And she had that cha-meleon quality of adapting to whatever the photo-grapher needed for his or her psyche.'

In Paris, unknown to Lisa, Penn once observed her in the dressing room, trying on a Balenciaga dress, moving her body around inside it, seeking the best way to show its form. 'Then she would come into the studio and say casually "How do you want me to be", as though she hadn't already given it considerable thought.' On all subsequent Paris trips the clothes would only be available at night, but another factor in the success of this series was that, uniquely, *Vogue* was allowed access to the clothes in daytime. A north-facing daylight studio was found on the seventh floor of an old photography school on the rue de Rennes; Penn's New York studio had no windows, and though he was a master at simulating the effect of daylight,

nothing could replace the 'simple three-dimensional clarity' of the real thing, which he was now free to indulge in.

By the end of the decade haute couture was in terminal decline, but for now Dior and Balenciaga were at a creative peak. It was as if Penn and Lisa sensed that here was the opportunity to record a historical moment that would soon pass, and that all the circumstances obligingly combined to ensure that the photographs were a triumph. Even fashion editor Bettina Ballard, normally so critical of photographers and models, admitted that Lisa 'was the most patient, working with her smooth, catlike movements, never jarring his mood, understanding his direction before he gave it', adding that Penn, whose 'mental torture' left everyone 'drained at the end of a sitting', this time 'worked like an angel... producing some of the strongest fashion pictures he ever took.'

As well as fashions in Paris, Penn began the first of his extended works of portraiture, the 'Petits Métiers'. He and Lisa travelled directly from Paris to London, where in another daylight studio he made portraits of eminent Britons for *Vogue* and continued the series begun in Paris with photographs of London's 'Small Traders'. Here, 'sandwiched in between portrait sittings with T. S. Eliot and a fishmonger', Penn and Lisa were married at Chelsea Register Office. After their marriage they visited Sweden together every summer. In Sweden in 1990 they marked the fortieth anniversary of their wedding in a private ceremony. Penn wrote of Lisa in *Allure* magazine at the time, 'Each day is an enrichment.'

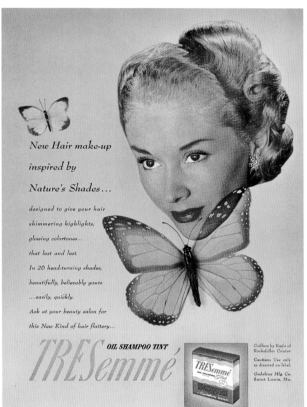

New Hair make-up
inspired by
Nature's Shades...

designed to give your hair
shimmering highlights,
glowing colortones...
that last and last.
In 20 head-turning shades,
beautifully, believably yours
...easily, quickly.
Ask at your beauty salon for
this New Kind of hair flattery...

TRESemmé OIL SHAMPOO TINT

ADVERTISEMENT FOR TRESEMMÉ 'OIL SHAMPOO TINT' IN VOGUE OCTOBER 15 1948

Other masterworks came from their collaboration – *Lisa in the Chicken Hat, Lisa in the Harlequin Dress* – and in Morocco in 1951, one of the last occasions Penn ventured outside of the studio for a fashion photograph, *Lisa in the Palace*. But the 'New Look' was fashion's last serious flirtation with romantic-ism. As Lisa observed, 'Fashion in New York changed after 1950. The emphasis was on clothes for the working woman. In the 1940s the war had been responsible for a more military look – fashions like uniforms – whereas when I started in Paris the aim was something much more lady-like, or exotic – fashion was for people of leisure.' Liberman desc-ribed how Lisa's 'severe and classic visage reached the public just as a woman's role was evolving into a vital self-confident presence in the world' and believed that 'she sent out a clear conception, maybe a revolutionary one, of the modern woman.'

If Lisa was ambivalent about the direction fashion was taking, she nevertheless struck up a fruitful working relationship with her friend Frances McLaughlin-Gill, who had joined *Vogue* in 1943, and was one of the photographers whose outdoor location work reflected fashion's turn towards 'realism'. From 1949 the English photographer Norman Parkinson spent part of each year in New York for American *Vogue*, making ebullient photographs of models in busy urban situations. 'I always loved to work with Parks,' said Lisa, 'though I was always a little shy with him – he was so overwhelming and elegant.' Milton Greene, who made some beautiful photographs of Lisa, represented a younger generation, and his working methods anticipated the photo-

graphers of the 1960s: 'His was one of the first studios with music playing all the time. It was wild music too, and *loud*. I think he did it partly to isolate himself from the editors, so they wouldn't interfere.'

After the birth of her son Tom Penn in 1952, Lisa only modelled intermittently, and mostly for old friends such as Frances McLaughlin-Gill and Louise Dahl-Wolfe. But her creative urge was undiminished. She had always enjoyed photography, and in 1949 had thought of taking it up professionally. Photographs she made at that time of her sister Lillian confirm her considerable potential as a camerawoman, and she worked for a while on *Ladies' Home Journal* in conjunction with fashion editor Willela Cushman. Unfortunately this career came to a premature halt when her darkroom in New York had to be converted into a nursery.

Lisa's career as a fashion designer was perhaps even more distinguished. She had always designed her own clothes, and in 1953 began to design dresses to be worn in her husband's advertising photographs – for example, in notable Penn ads for Plymouth cars and De Beers diamonds. Her own clothes were widely admired, and she was encouraged to try to sell her designs. John Kloss, who became an inventive avant-garde designer himself in the 1960s, reminisced: 'She would sometimes put a colour on and roam the apartment in those wonderful earthy tones. Lisa wanted to know how the fabric moved or how it looked curled up on a sofa. She had the most remarkable colour sense. I'd drape her ideas and translate them into a design and our one seamstress would do the rest. It was a marvellous time for me and so different from what I learned in Paris.' Lillian Bassman, who revolutionized the photography of lingerie, said of Lisa's designs: 'I used to comb the market for lingerie I could use and hers was remarkable – very simple but very beautiful.' People began to order special evening gowns, and Lisa designed a line of at-home clothes for the department store Lord and Taylor; a photograph by her friend James Abbe Jr shows Lisa wearing one of her own practical yet elegant creations. Lisa carried on this business until 1962, when the Penns had to vacate their Central Park West apartment, which was in a building due for demolition.

At this time Lisa was already spending more time at weekends in her sculpture studio at the Penns' house in Long Island. She enrolled in painting and sculpture classes at the Art Students League and eventually, so that she could spend more time in her studio, the Penns moved out to Long Island completely, Penn commuting into Manhattan daily. Lisa's final career was in many ways the most remarkable, and will doubtless be the subject of a separate book. Her paintings and sculptures were first exhibited in group shows in 1968, and in 1983 and 1987 she had successful one-woman exhibitions of bronzes and etchings at New York's Marlborough Gallery. Her creative spirit touched every aspect of her life. I asked her if she saw any connection between her sculpture and posing for photographers: 'When I am making sculpture my hands work the material but the form evolves from my subconscious, revealing something of which I may not have been aware. The shape expresses my feelings. It is a mysterious and joyful process for me. I was a sculptor all my life – with materials and with my body, and I think that it was not so different when I was being photographed – I was a form in space.'

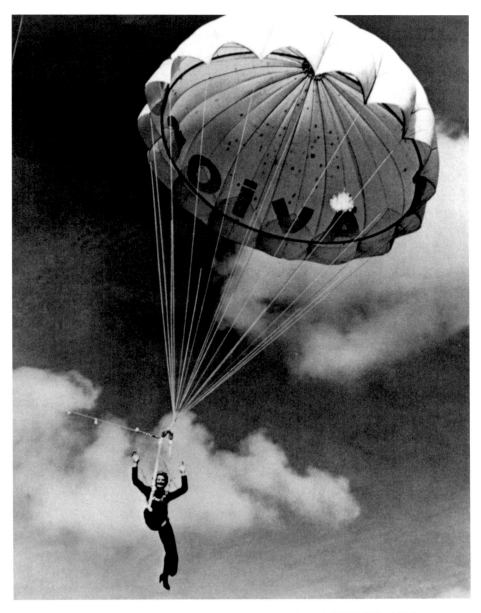

ELSA SCHIAPARELLI'S PYJAMAS FALLING FROM THE PARIS SKY, 1937.
PHOTOGRAPH BY JEAN MORAL, HARPER'S BAZAAR, 15 SEPTEMBER 1937

PLATES

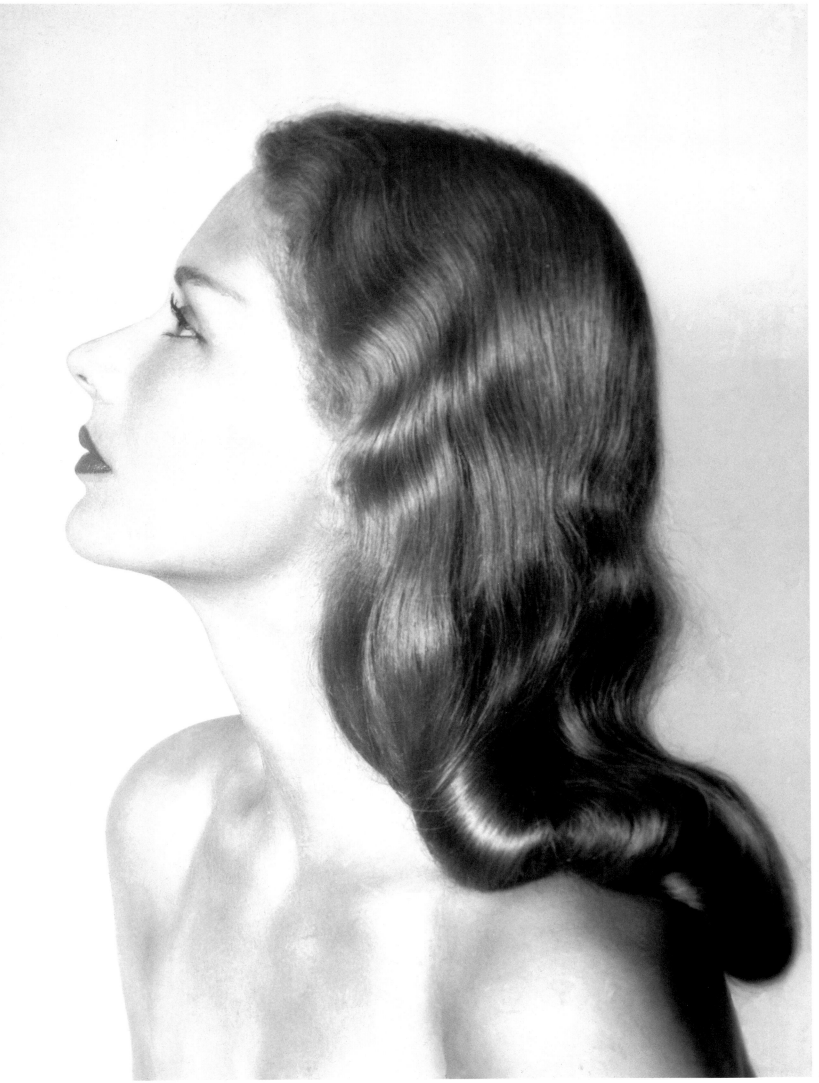

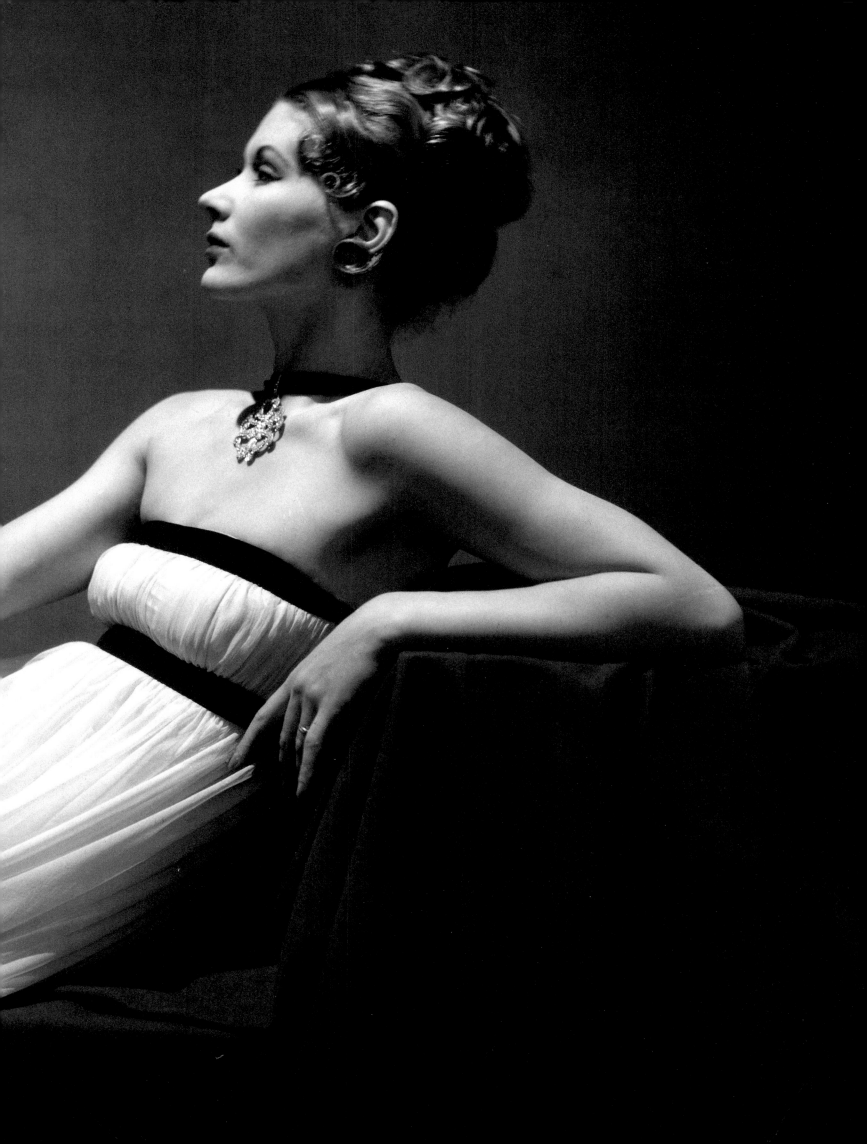

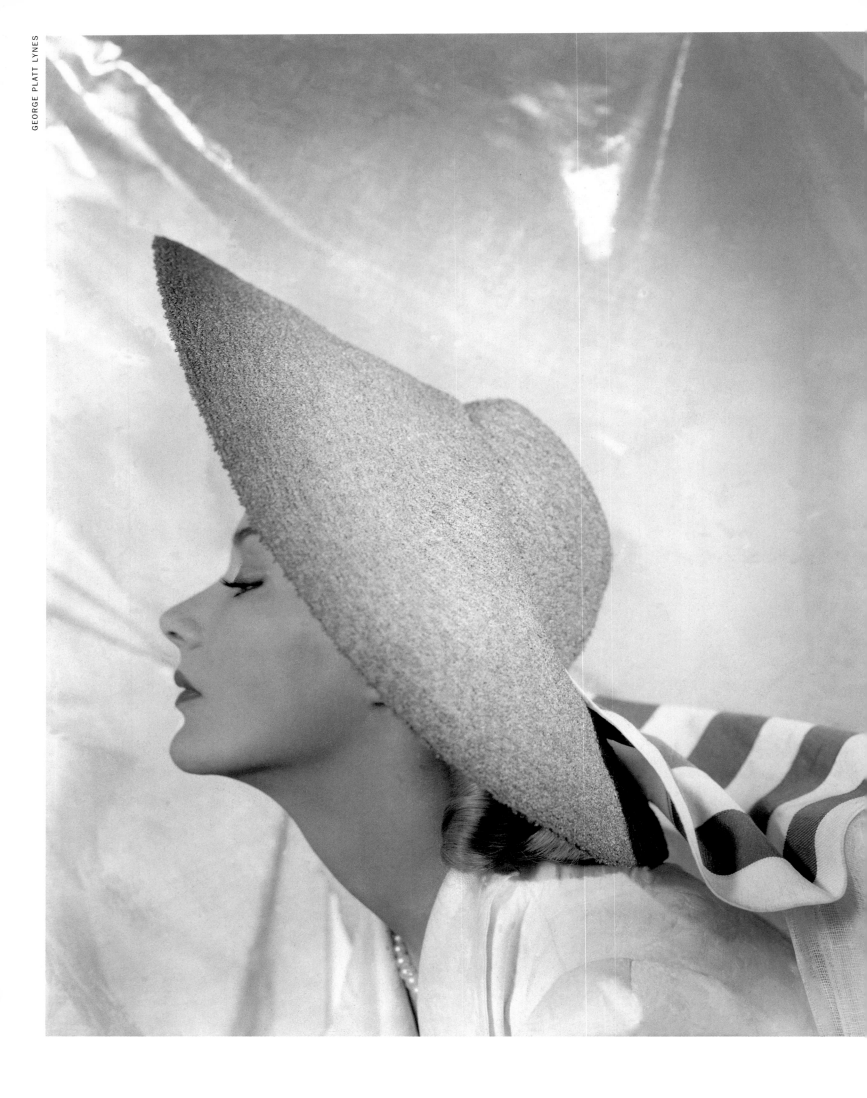

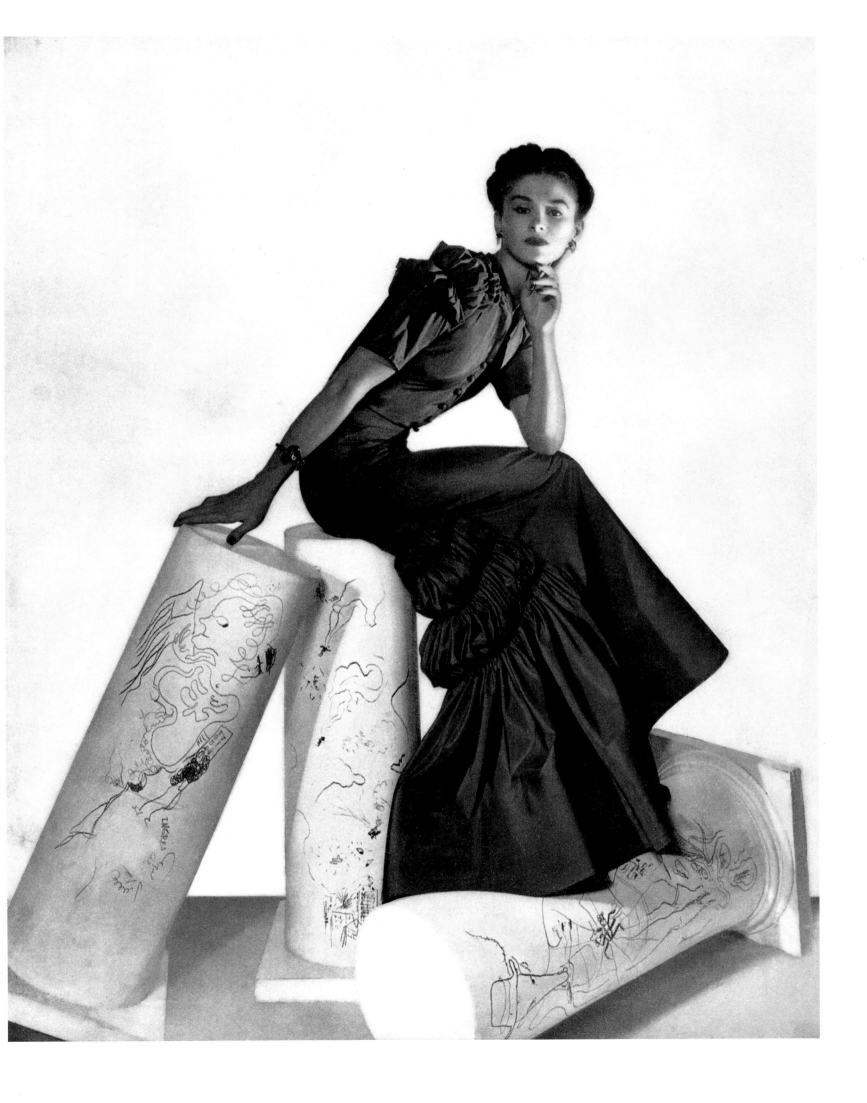

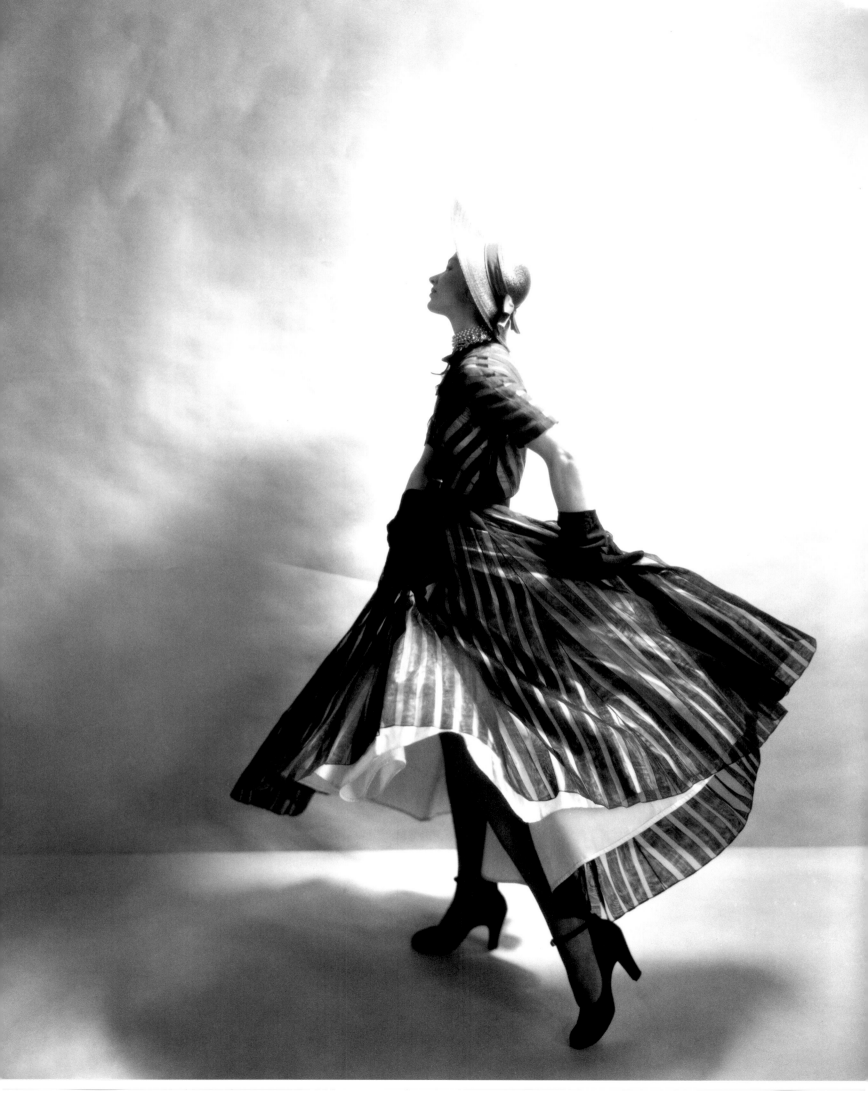

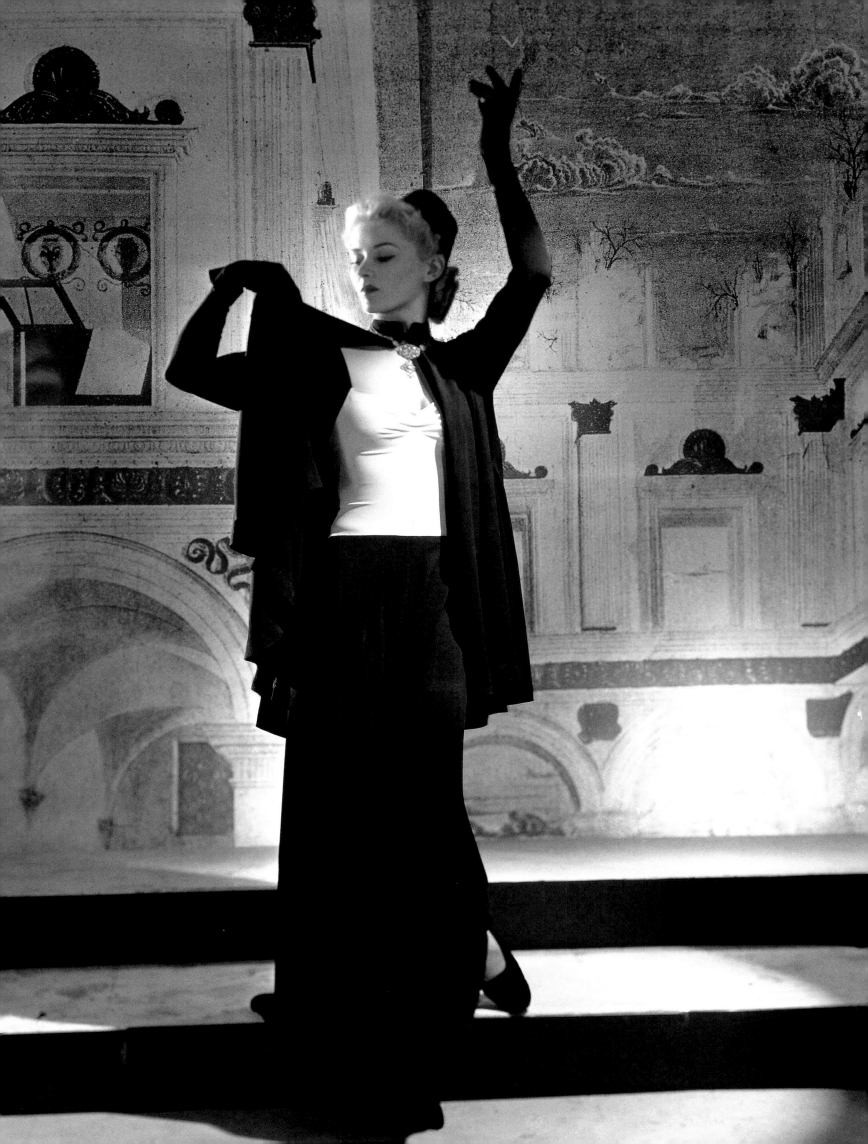

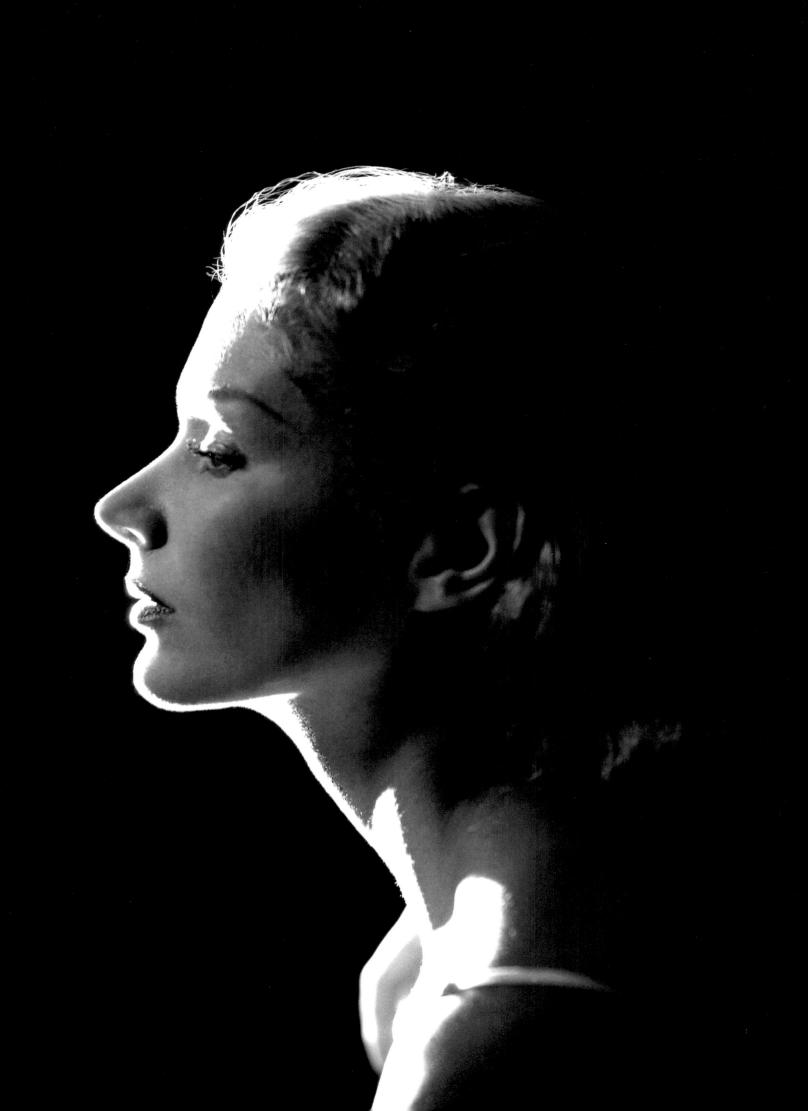

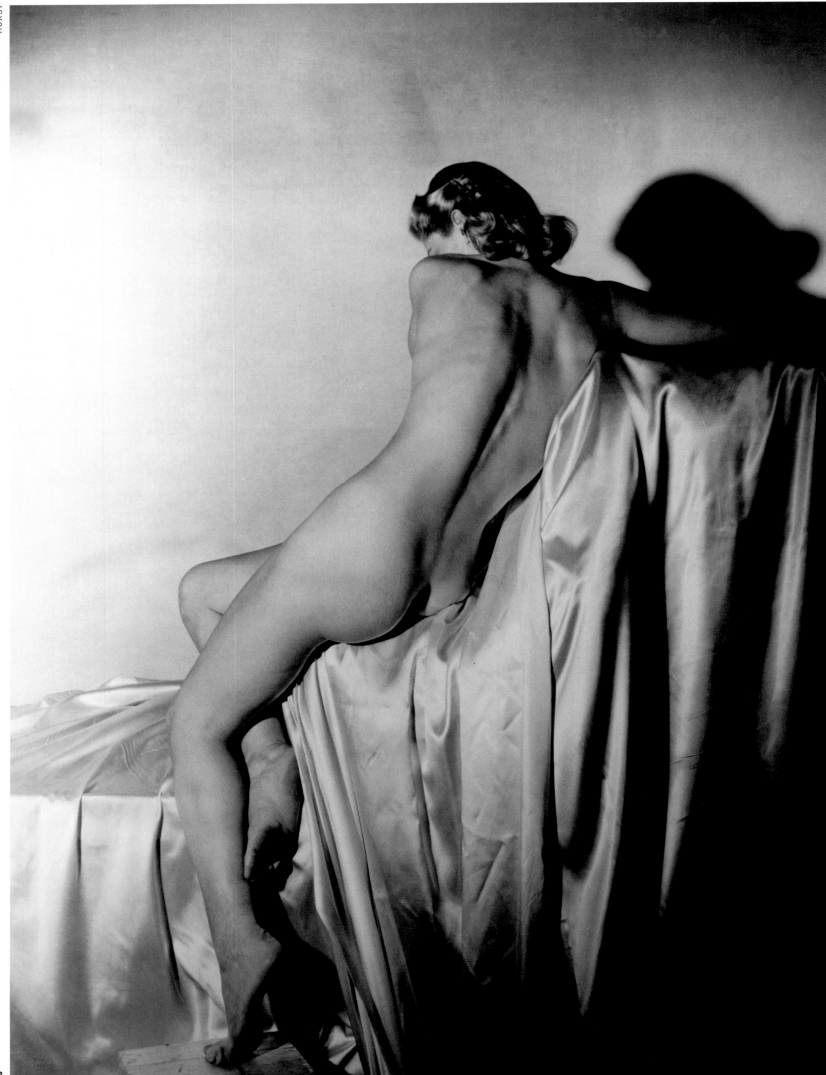

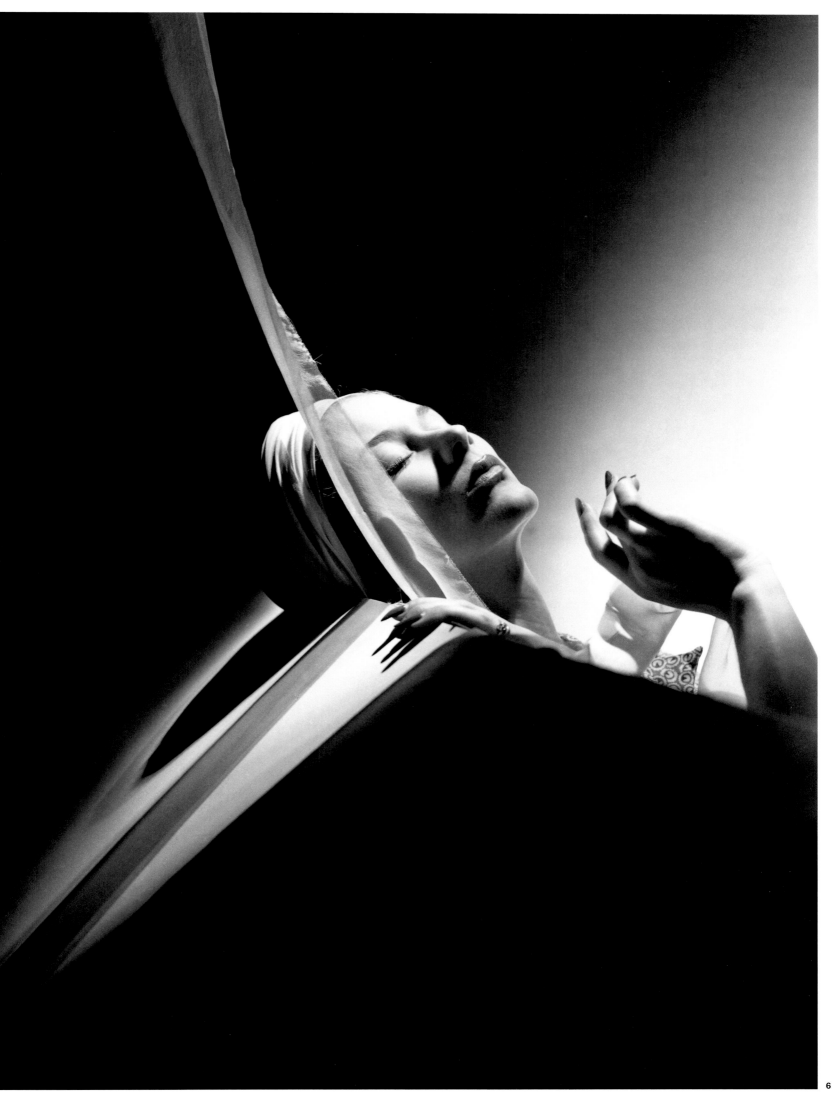

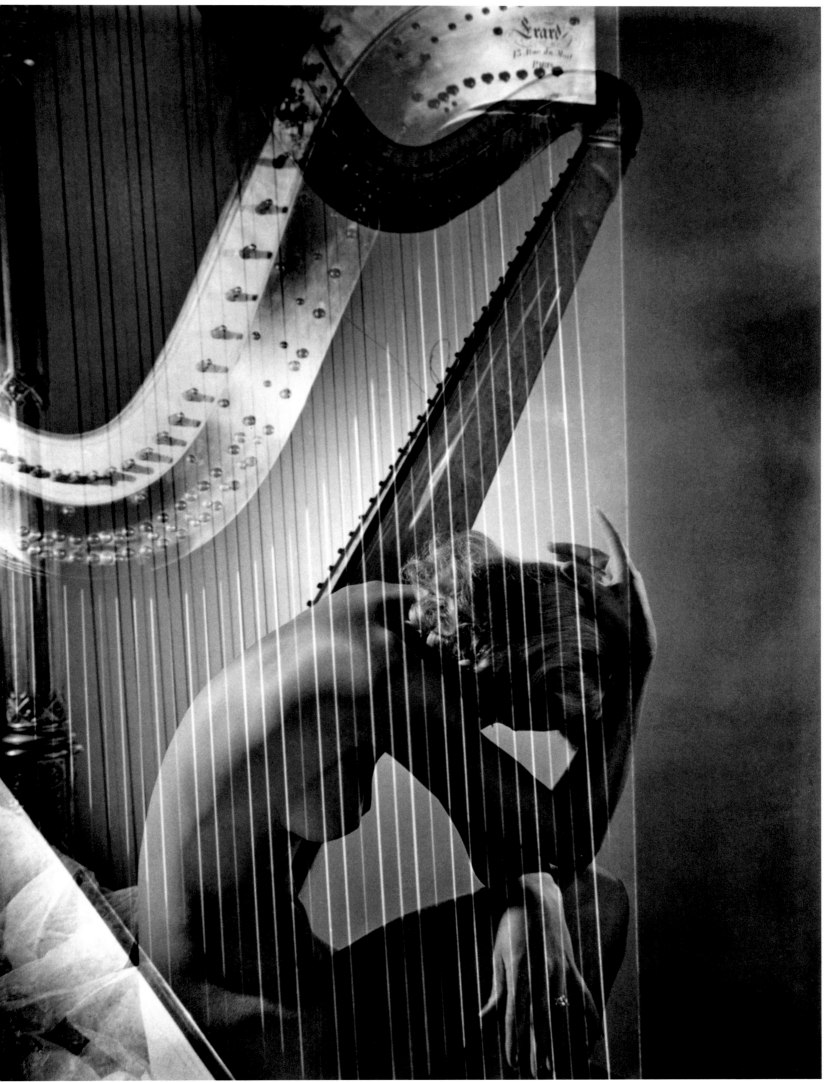

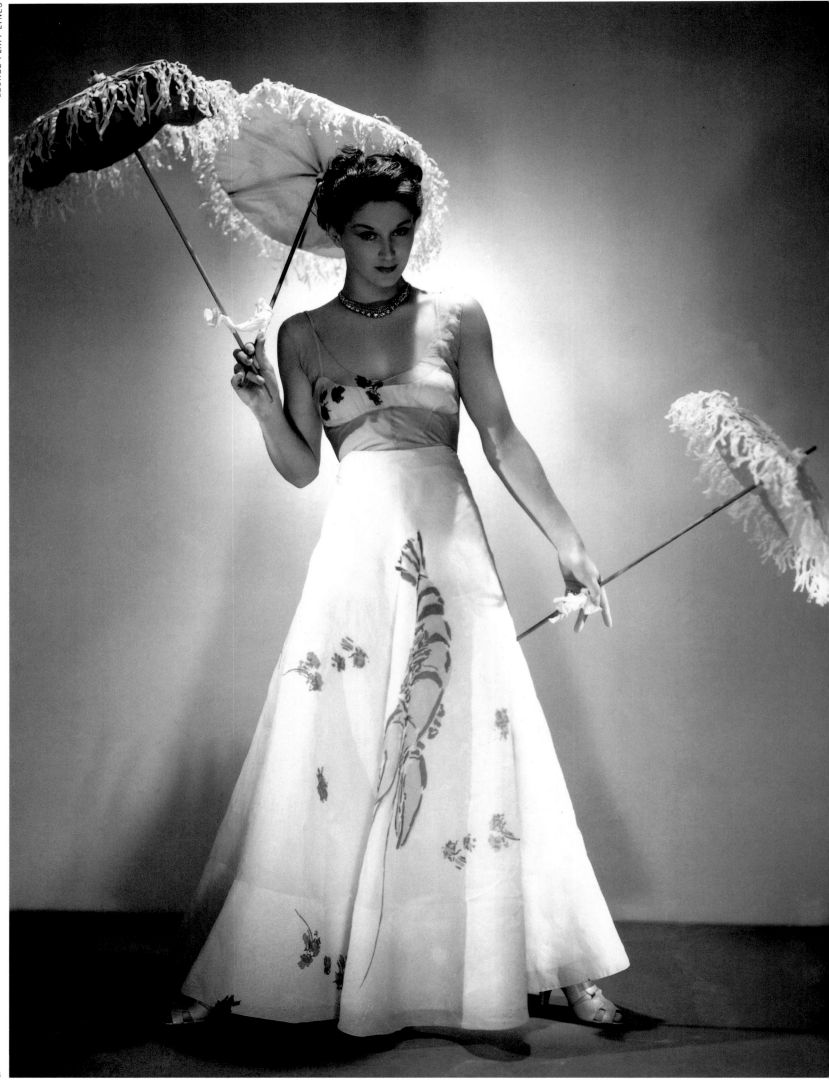

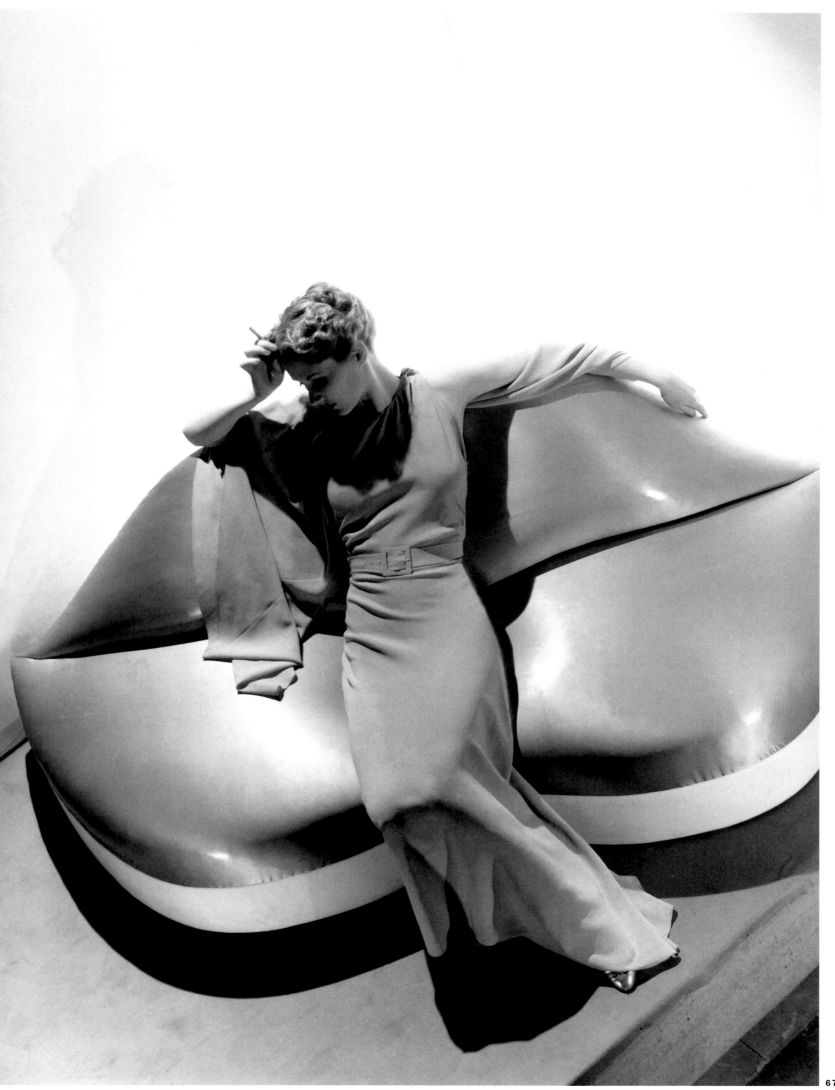

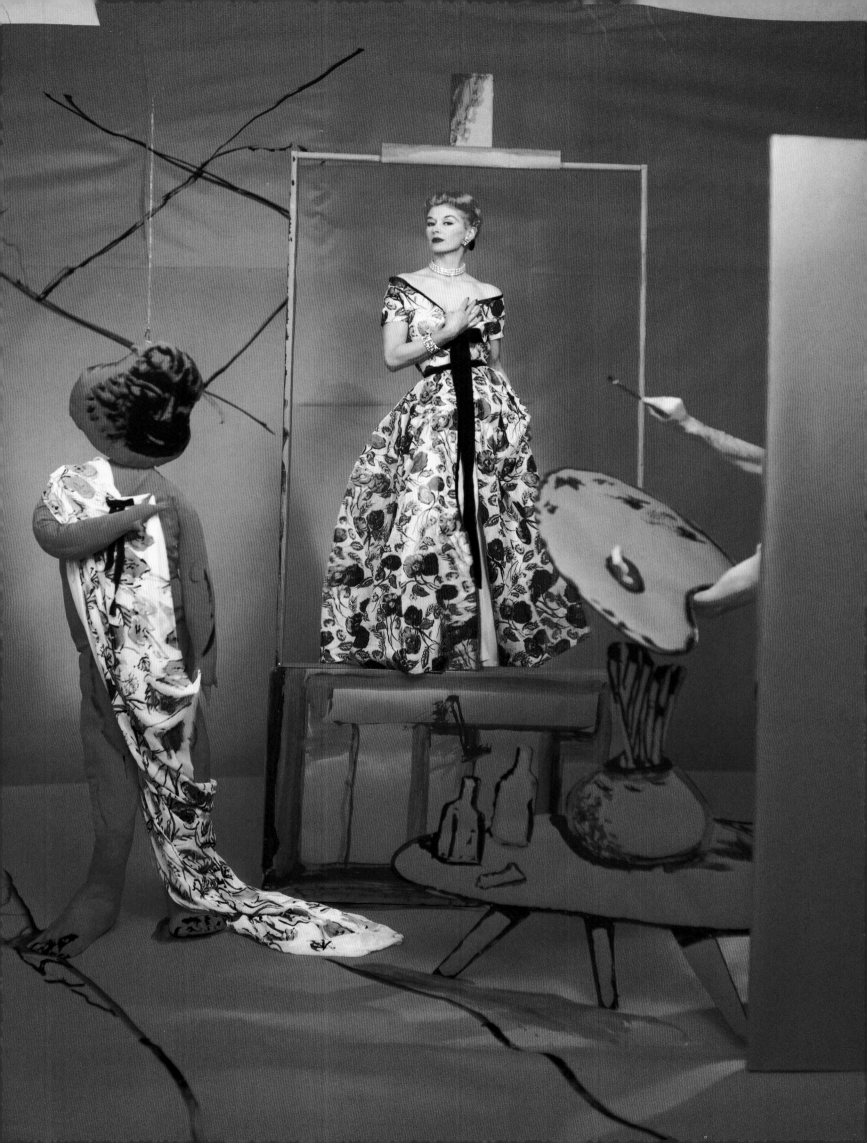

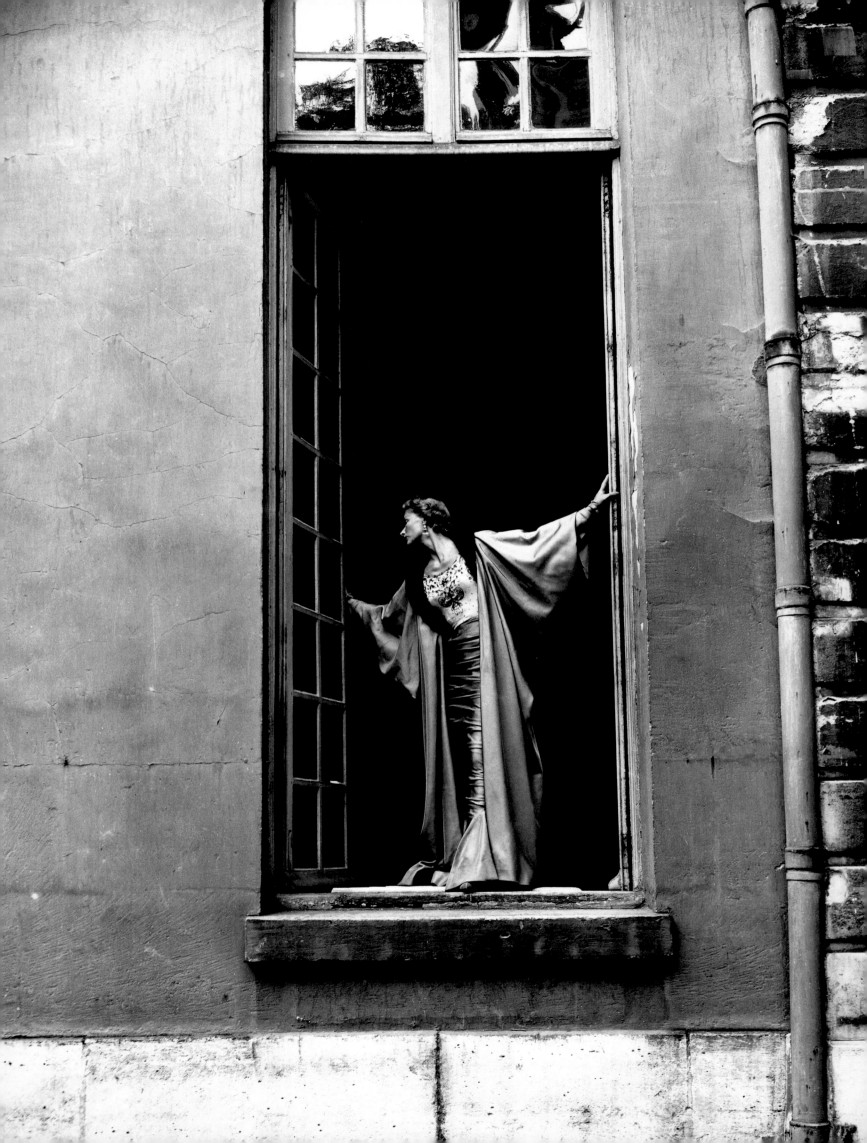

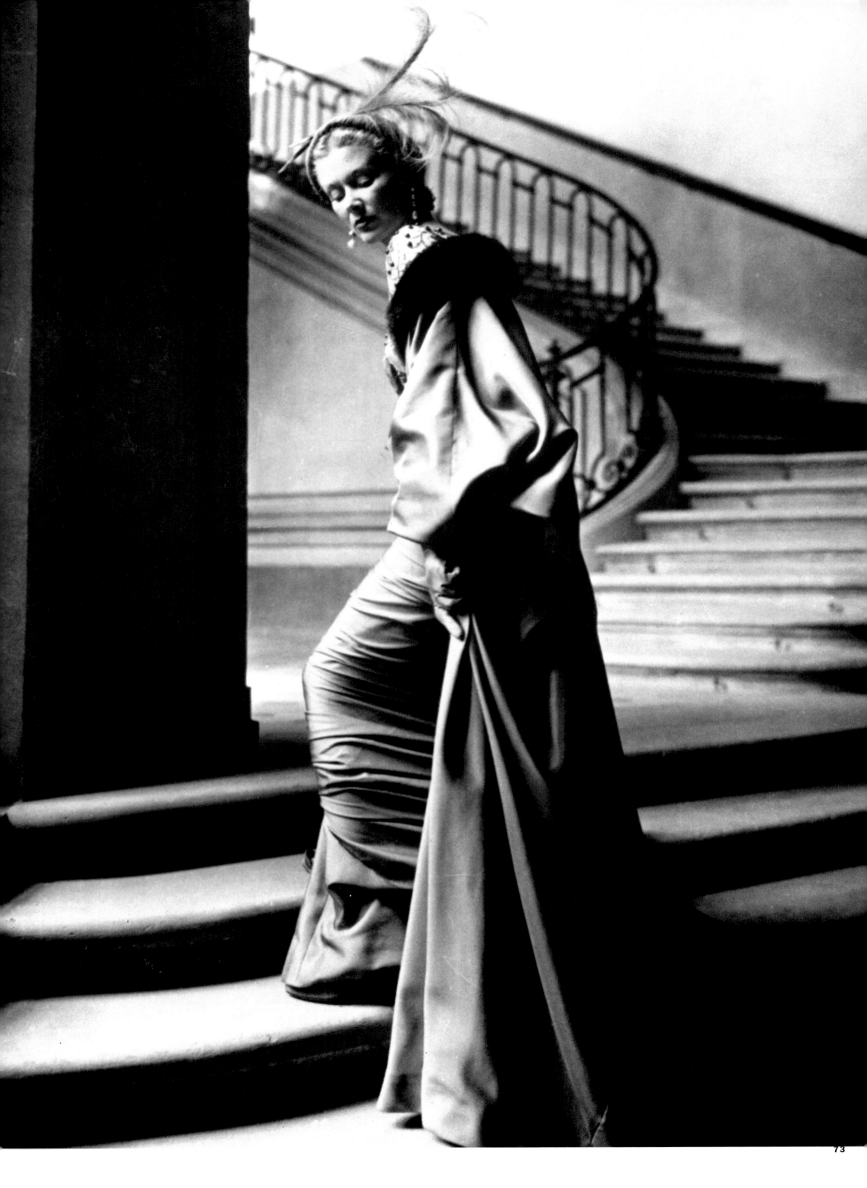

62 **HORST** 1940
NUDE NEW YORK

63 **HORST** 1940
'LISA WITH TURBAN' NEW YORK

65 **HORST** 1939
'LISA WITH HARP' NEW YORK
VOGUE 15 MAY 1941

66 **GEORGE PLATT LYNES** 1937
'LOBSTER DRESS', ELSA SCHIAPARELLI NEW YORK
HARPER'S BAZAAR APRIL 1937

67 **GEORGE PLATT LYNES** 1937
LISA SEATED ON 'MAE WEST'S LIPS', SOFA DESIGNED
BY SALVADOR DALI FOR JEAN-MICHEL FRANK

69 **HORST** 1953
'POPPY GOWN' BY PIERRE BALMAIN NEW YORK
VOGUE 1 MAY 1953

70–71 **FERNAND FONSSAGRIVES** 1949–50
RUE DE VARENNES PARIS

73 **HORST** 1939
MALAYAN TURBAN, LILLY DACHÉ NEW YORK
VOGUE 1 JANUARY 1940

75 **PHOTOGRAPHER UNKNOWN** LATE 1930s

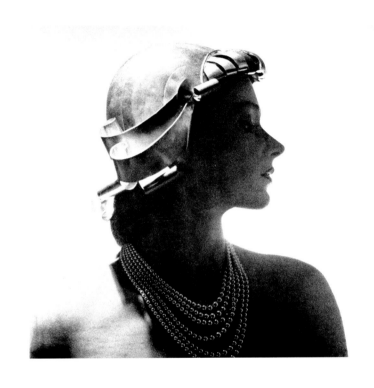

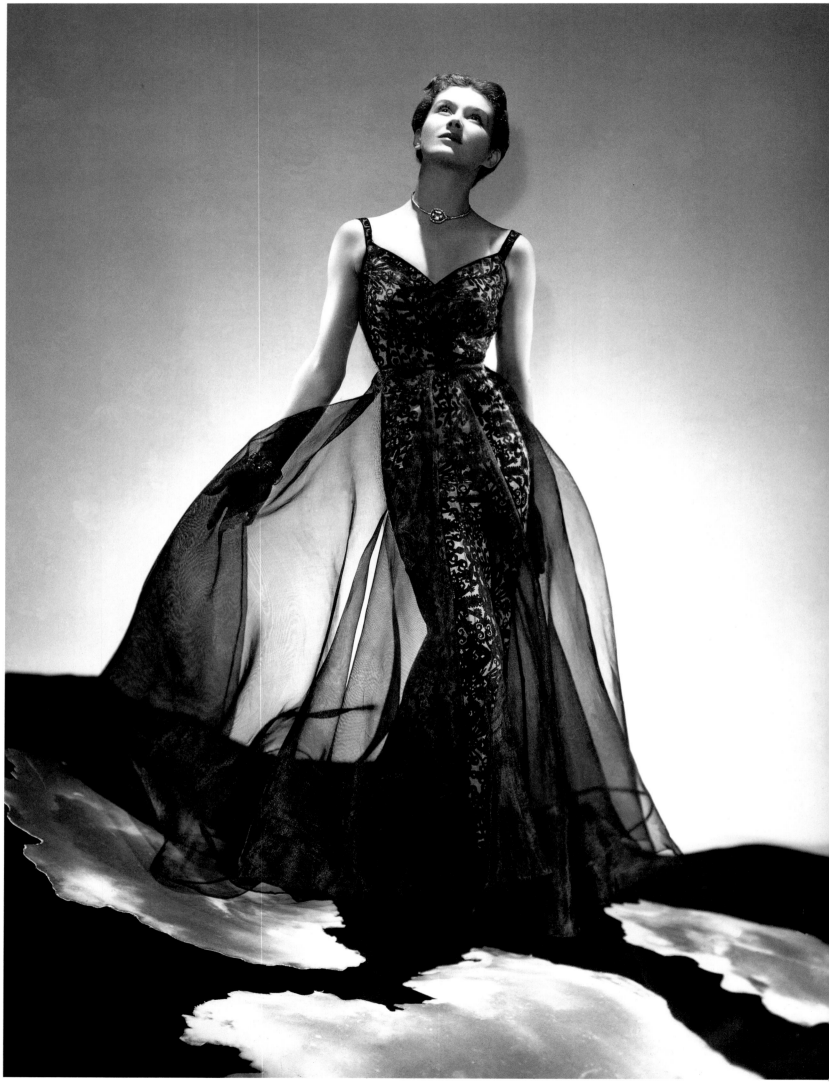

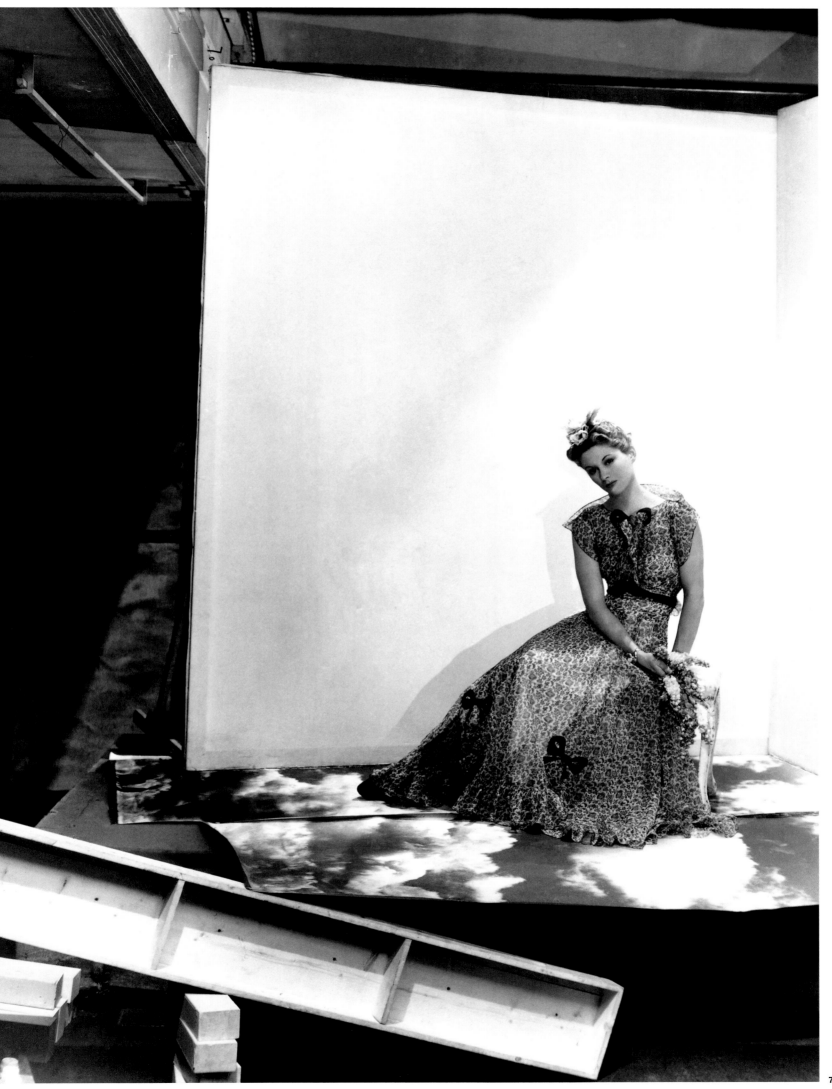

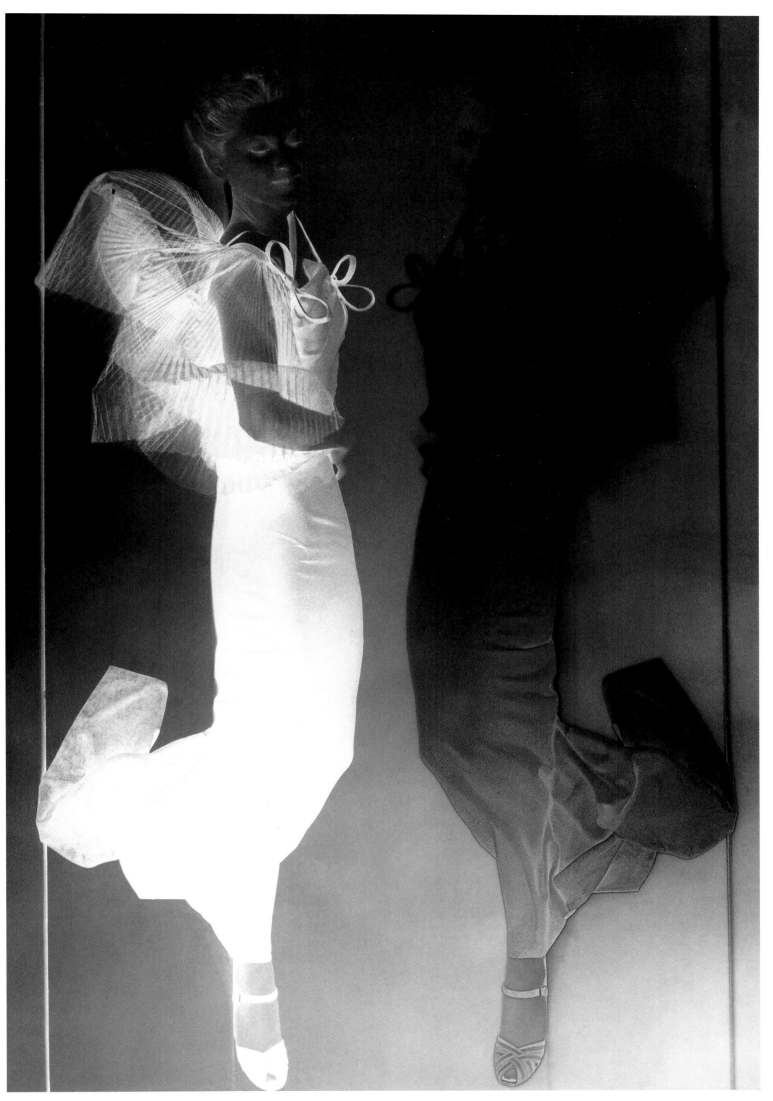

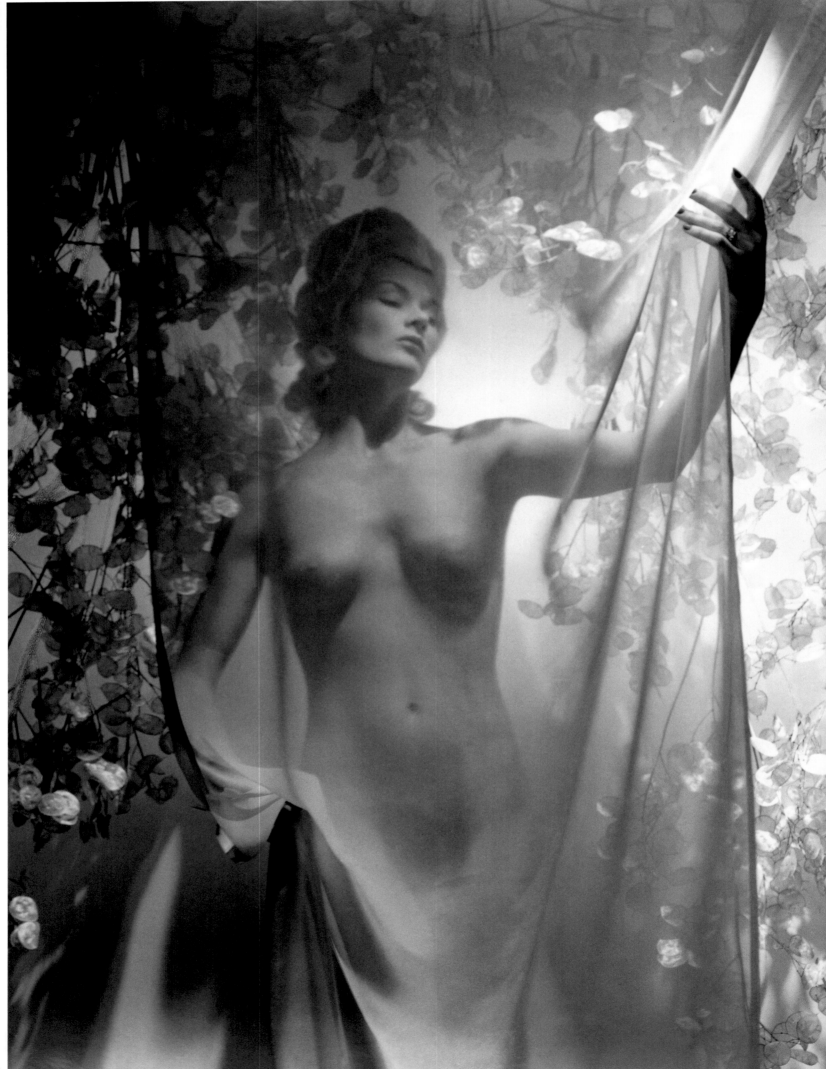

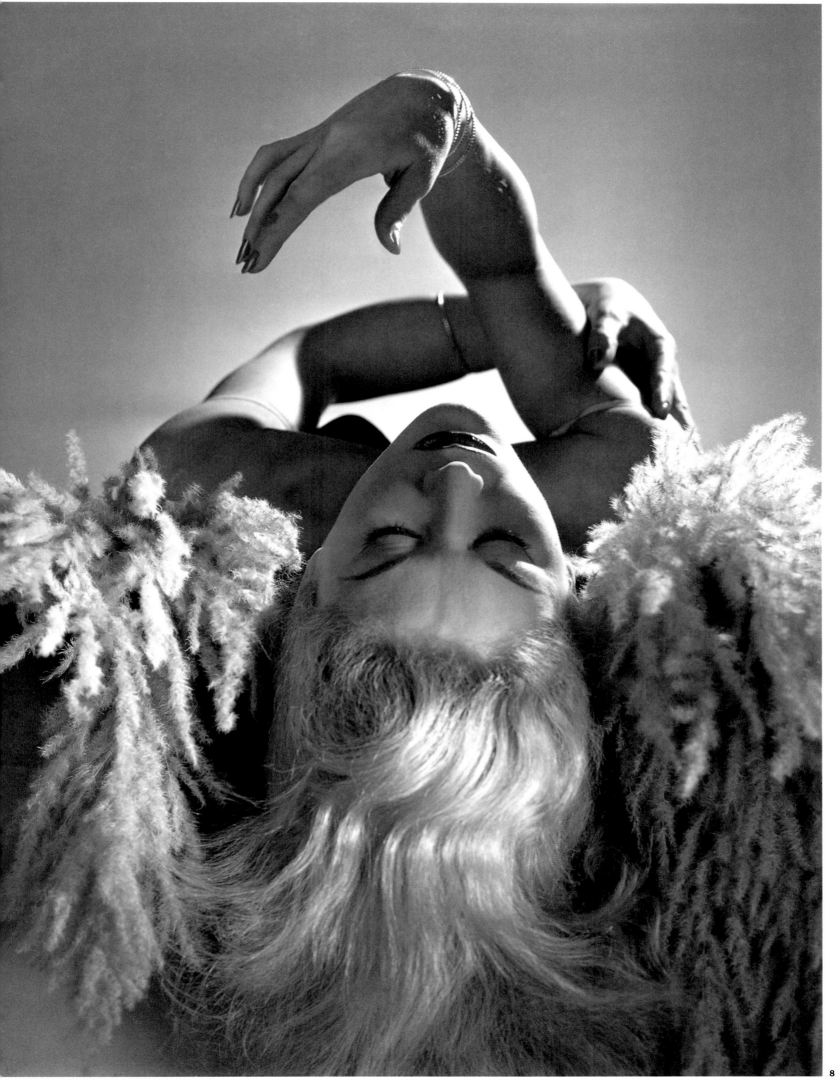

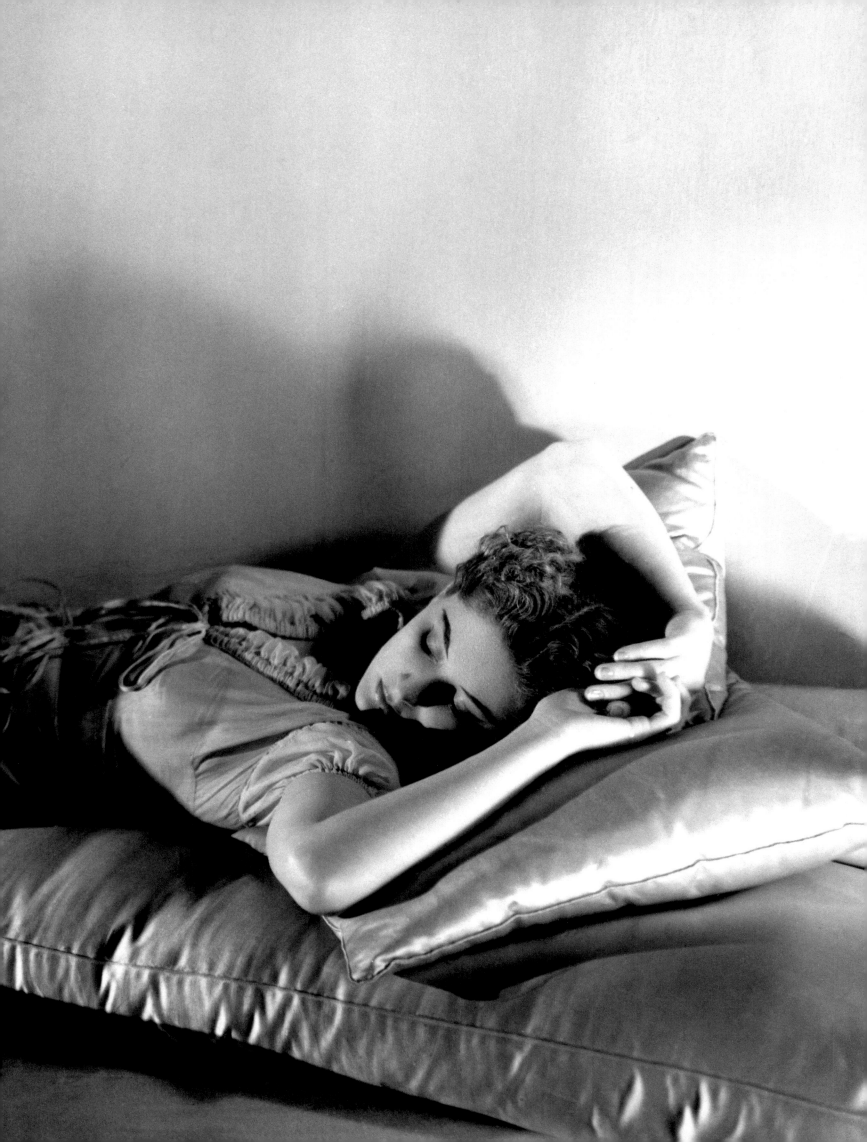

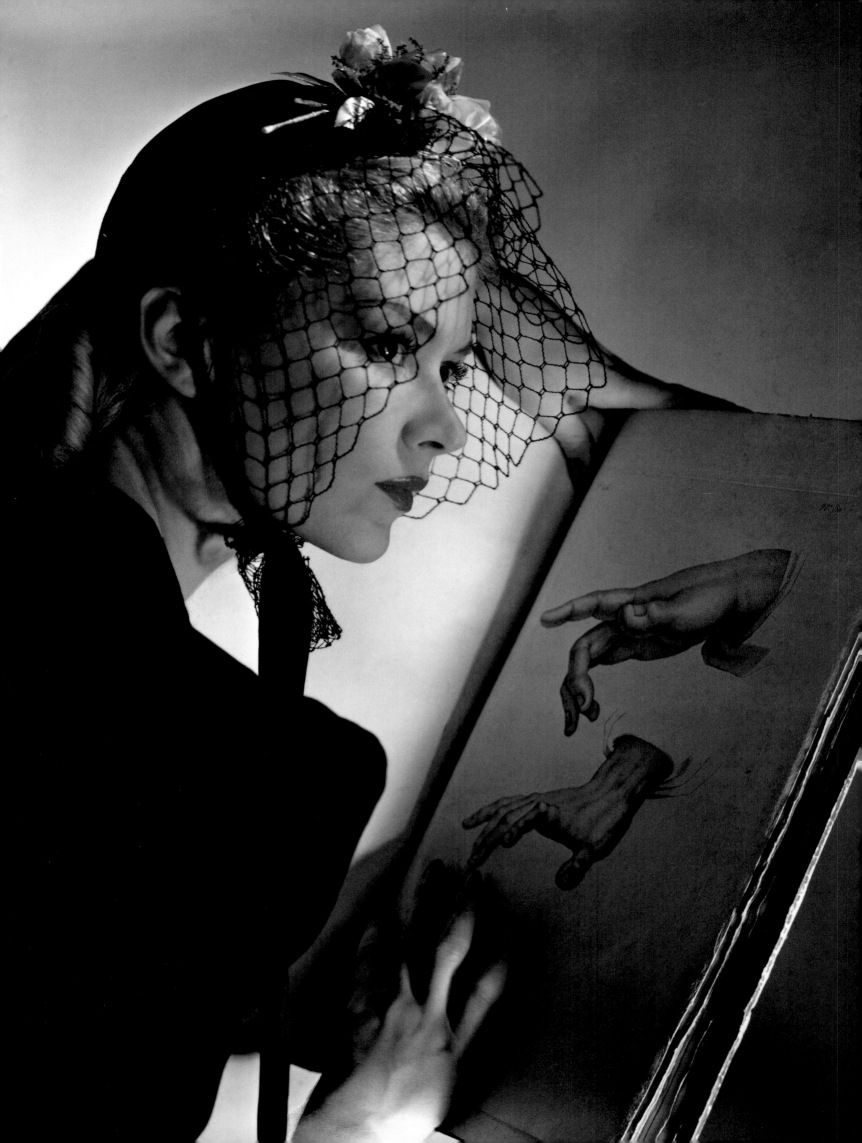

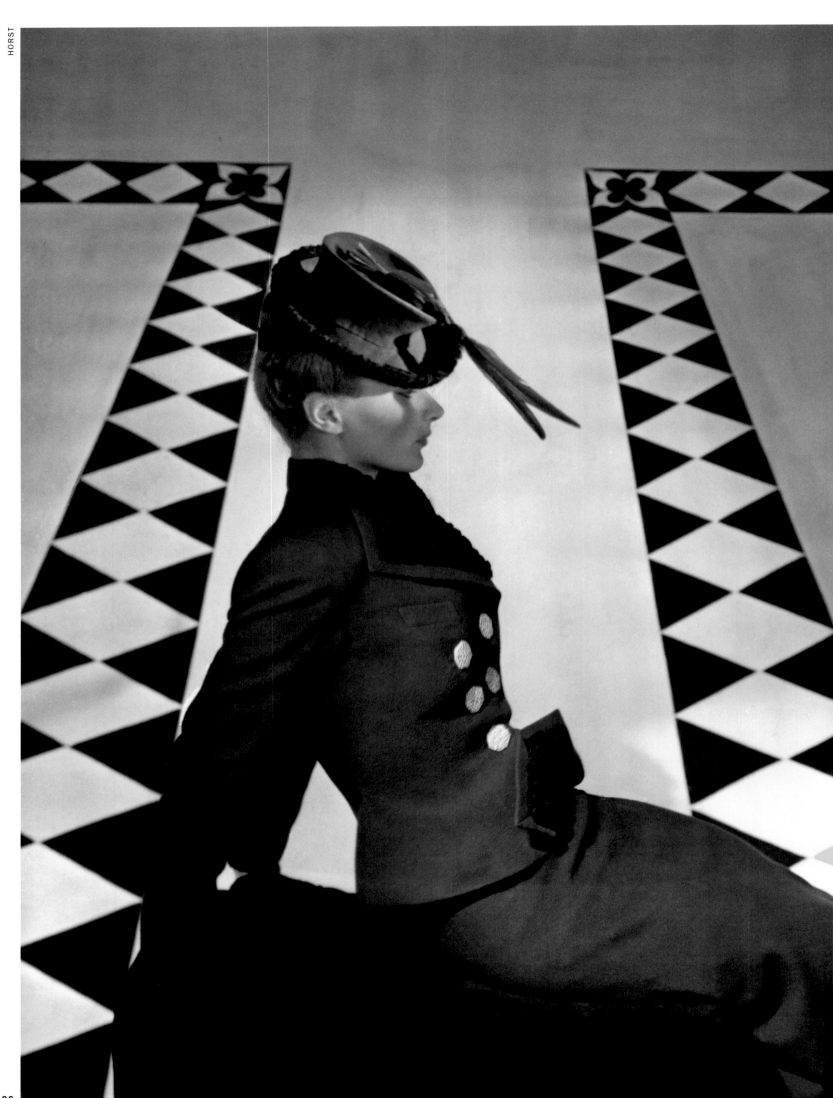

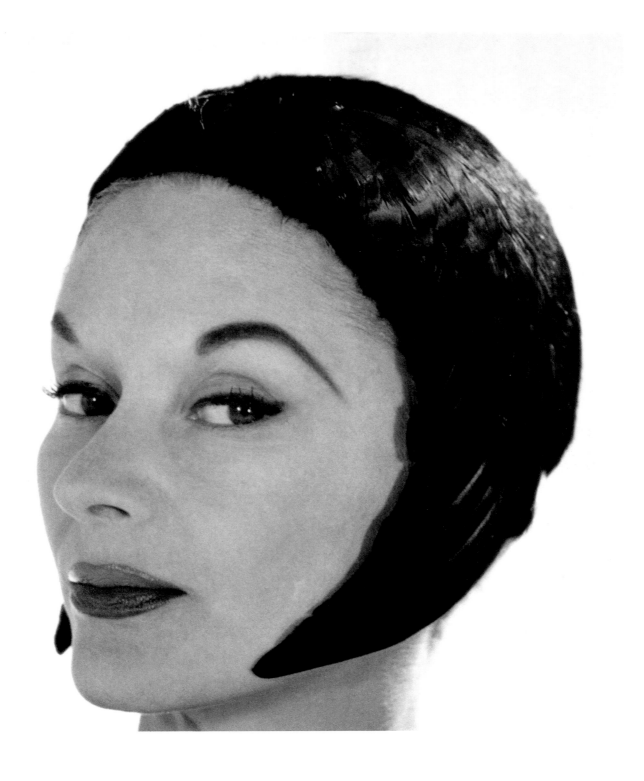

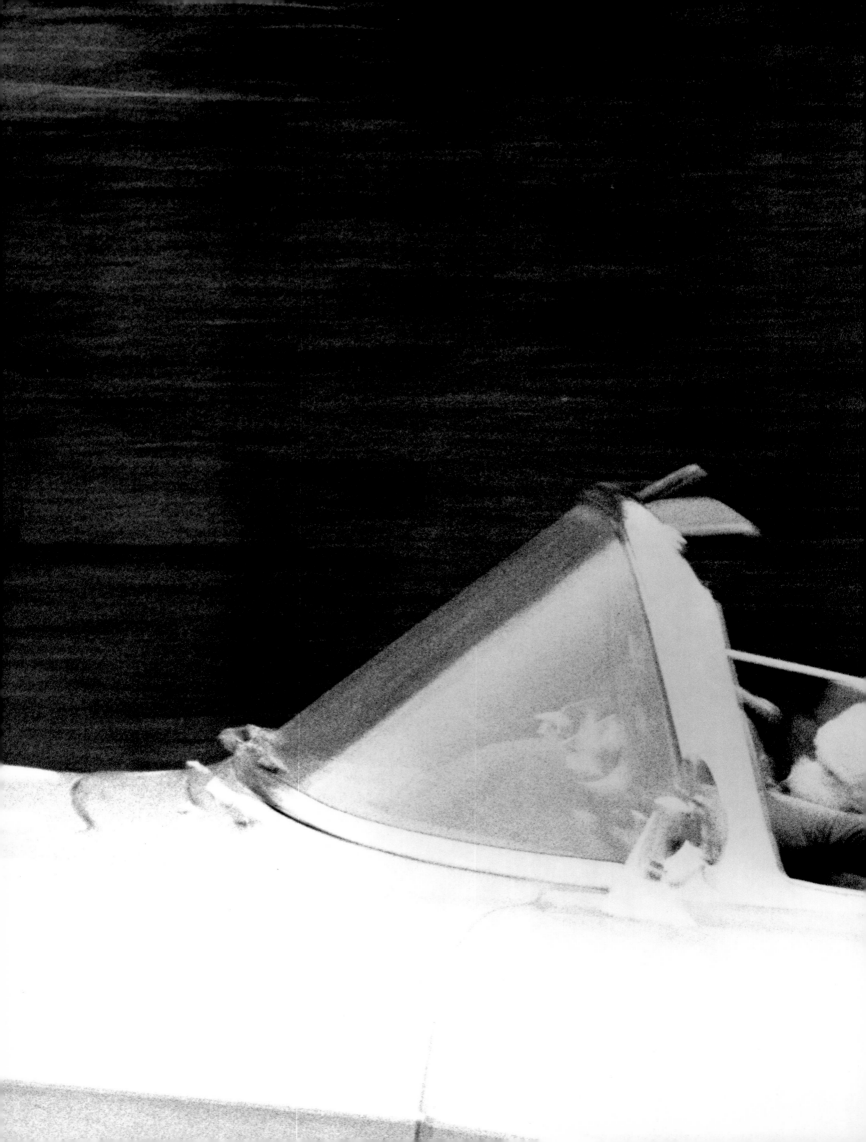

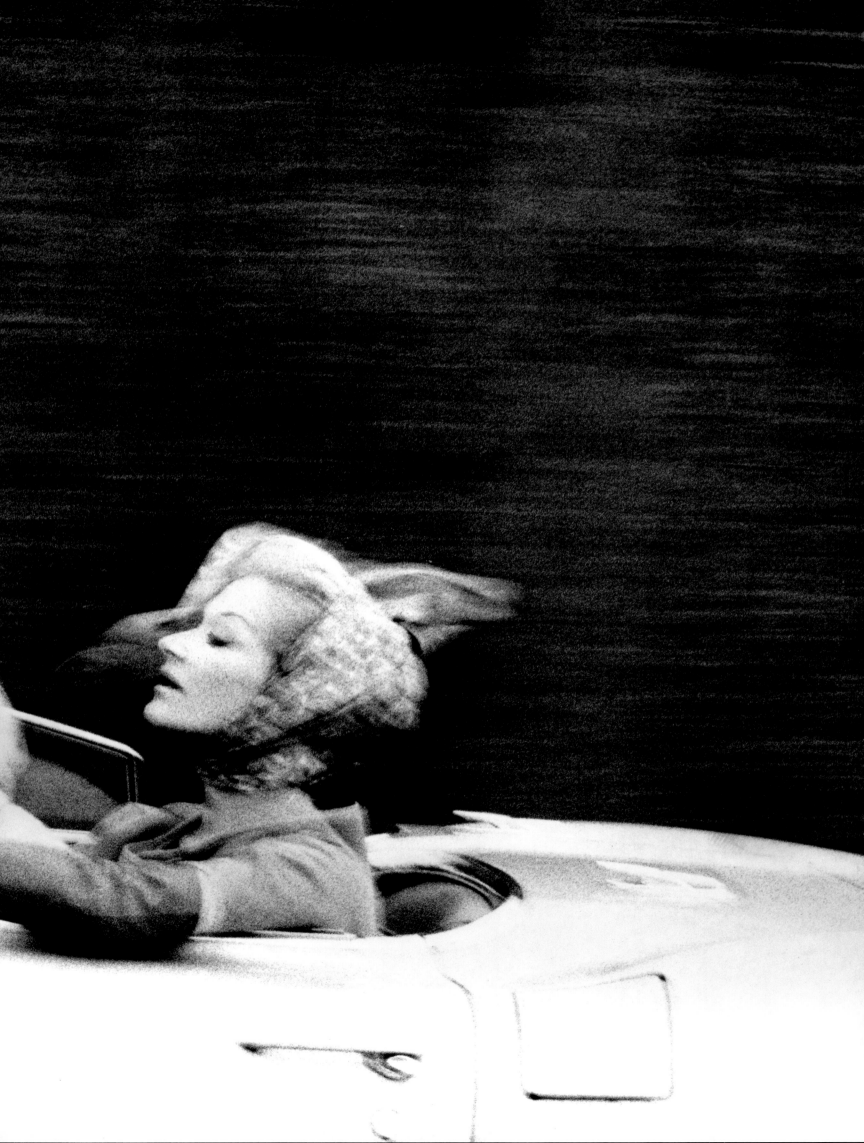

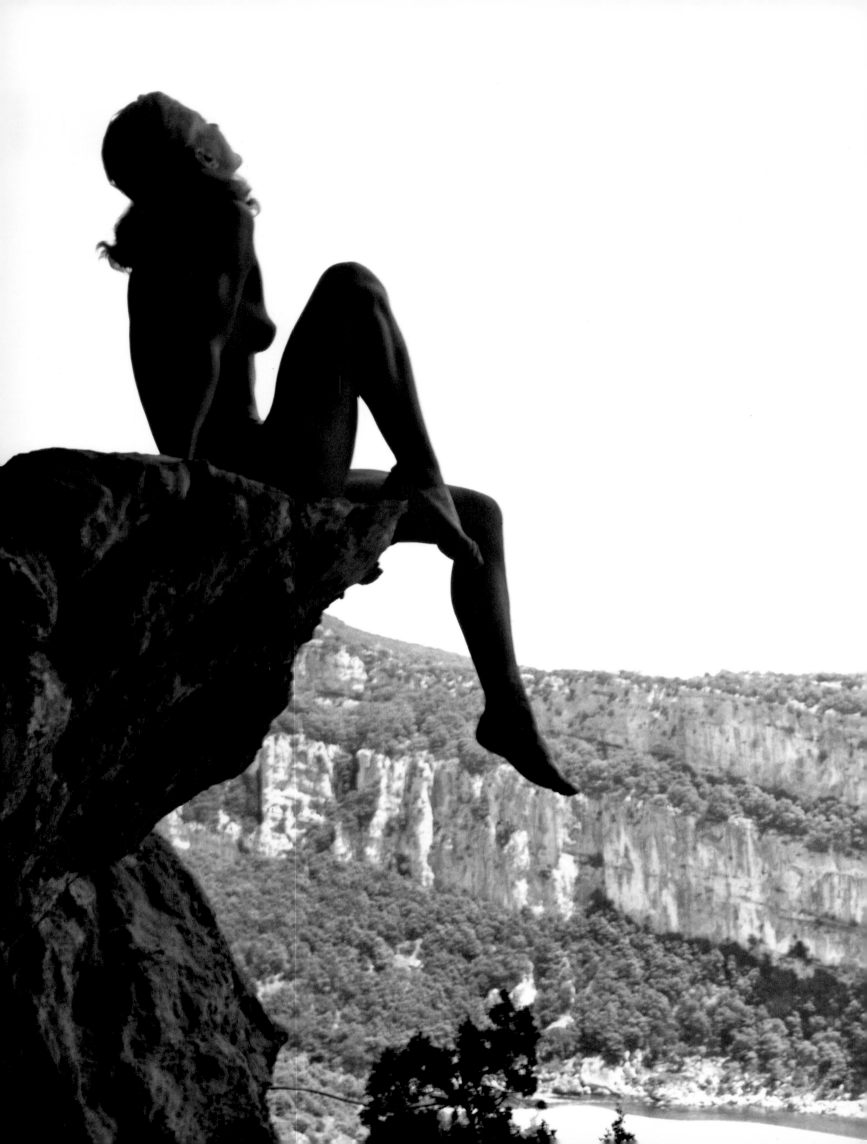

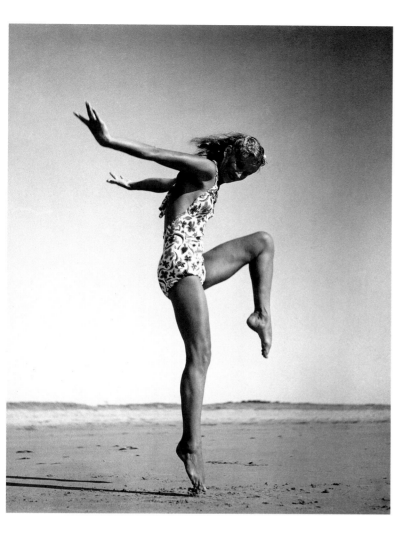

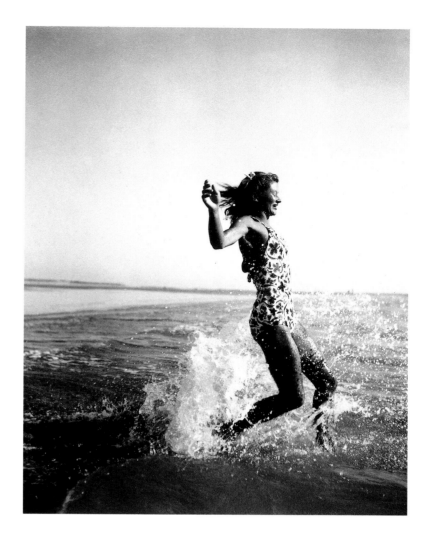

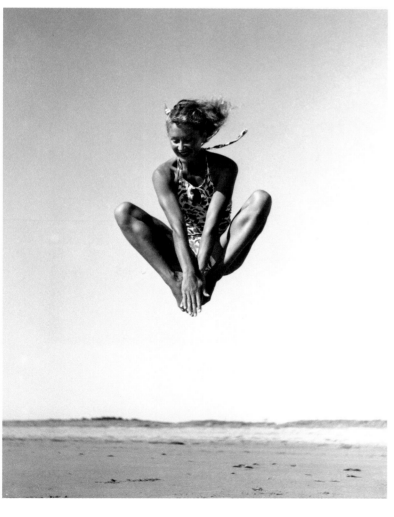

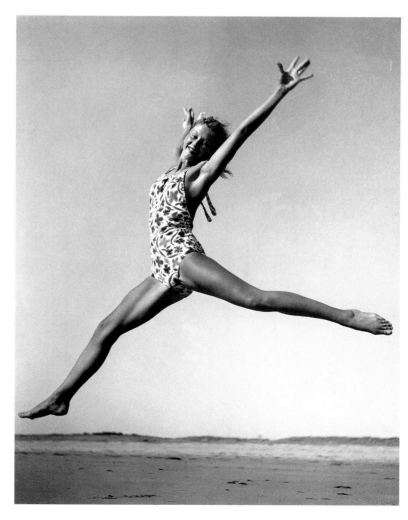

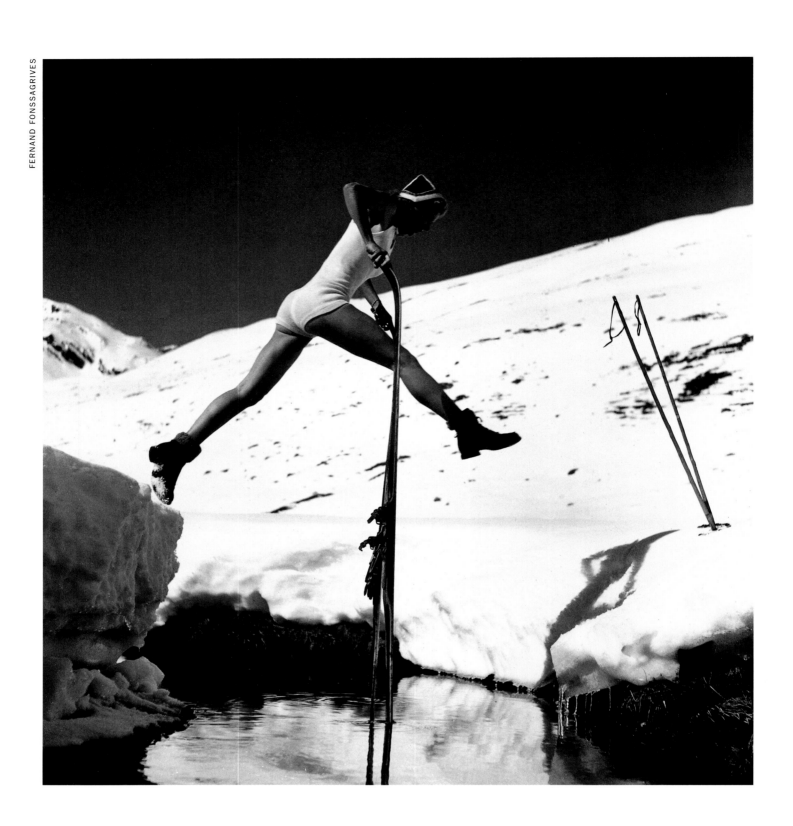

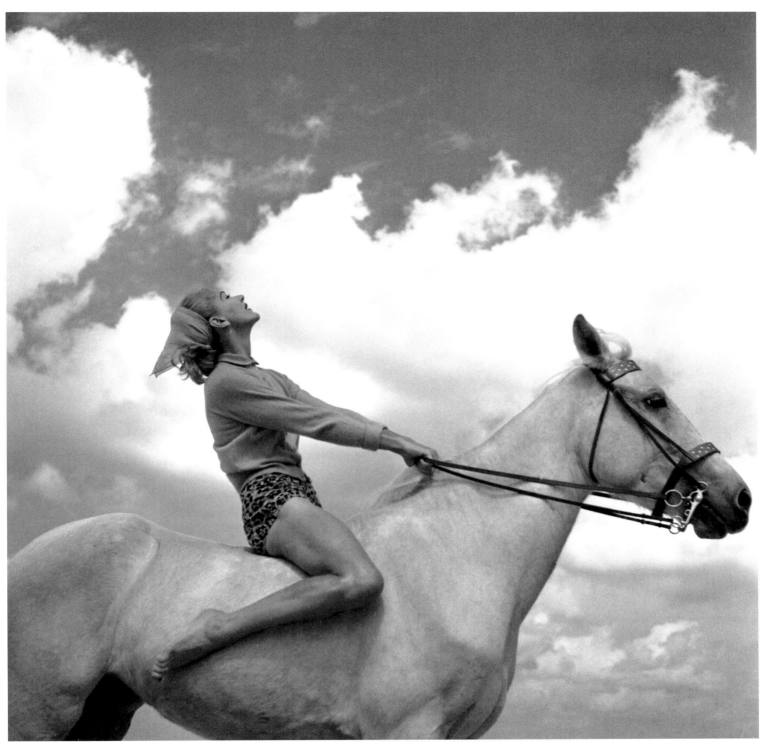

LOUISE DAHL-WOLFE

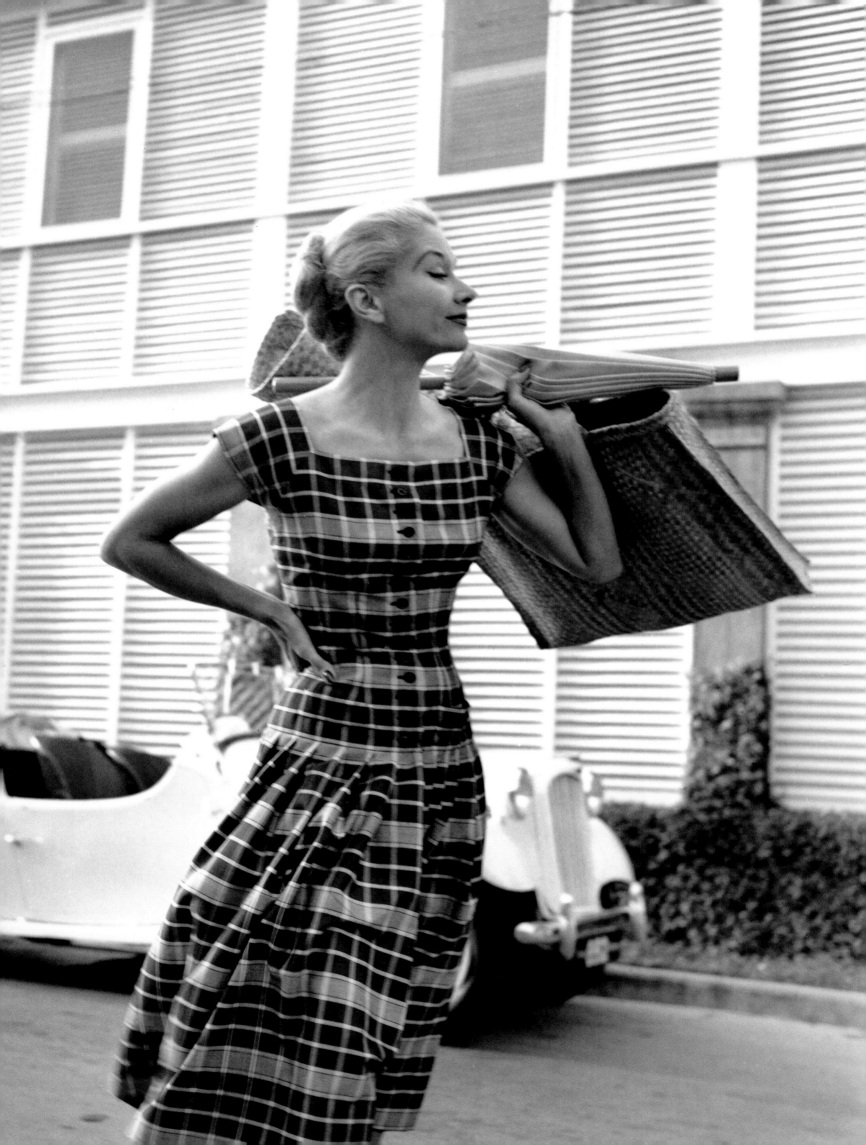

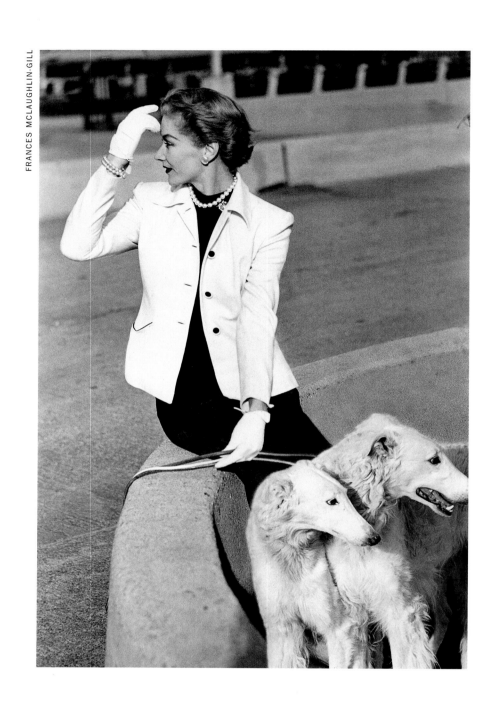

FRANCES MCLAUGHLIN-GILL

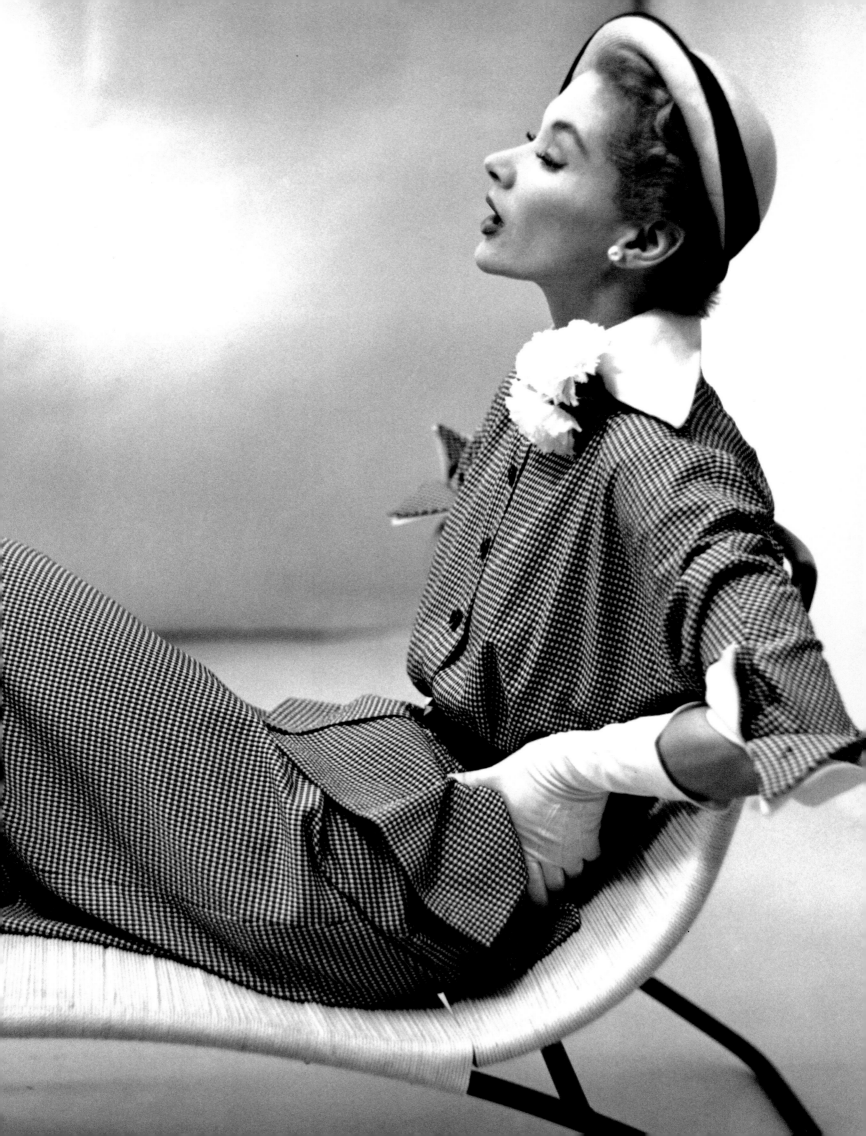

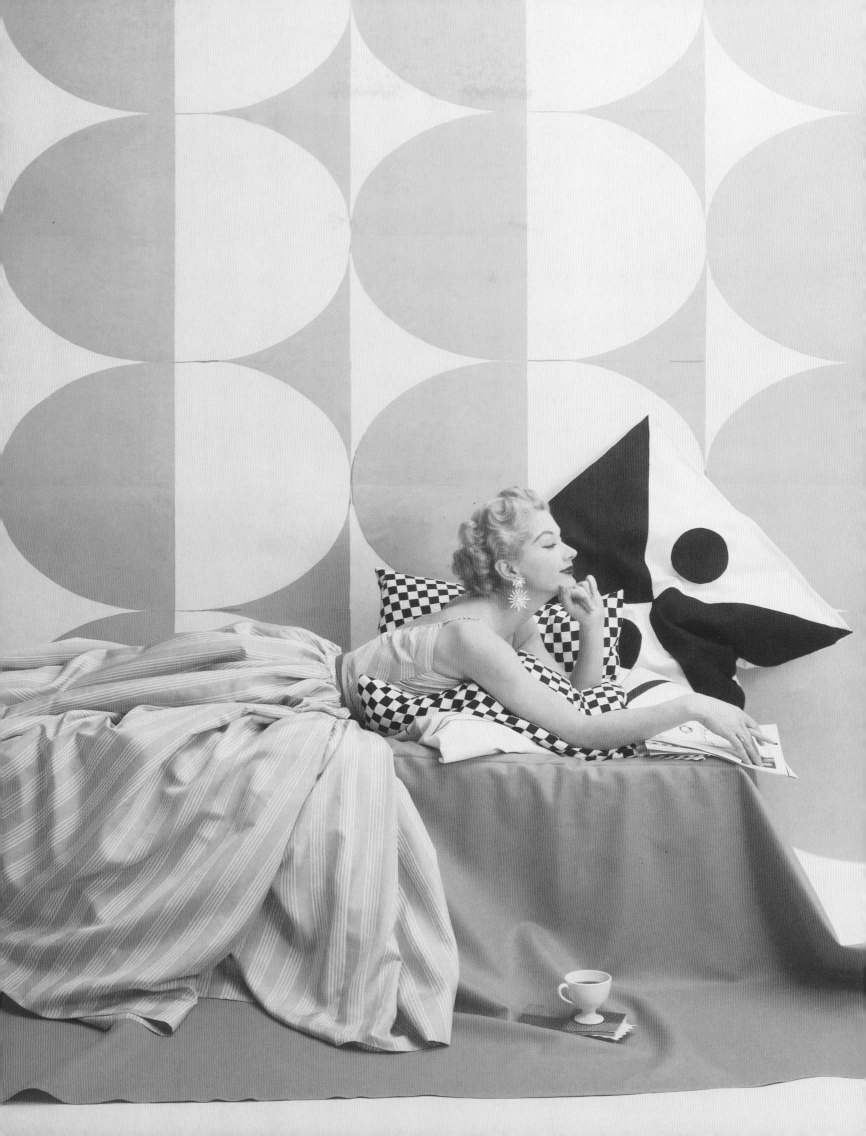

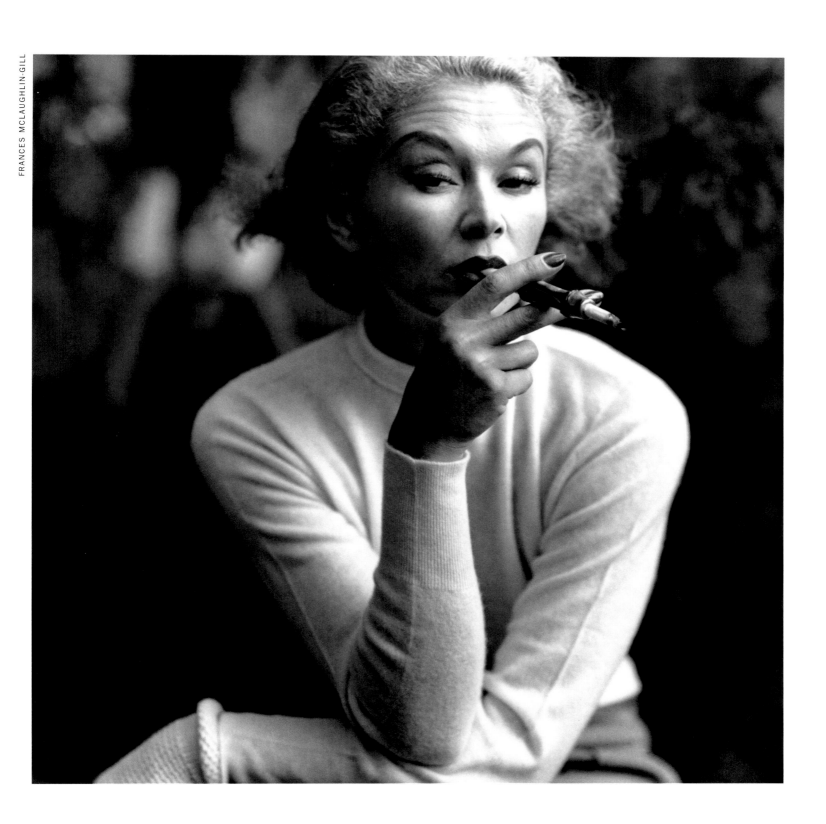

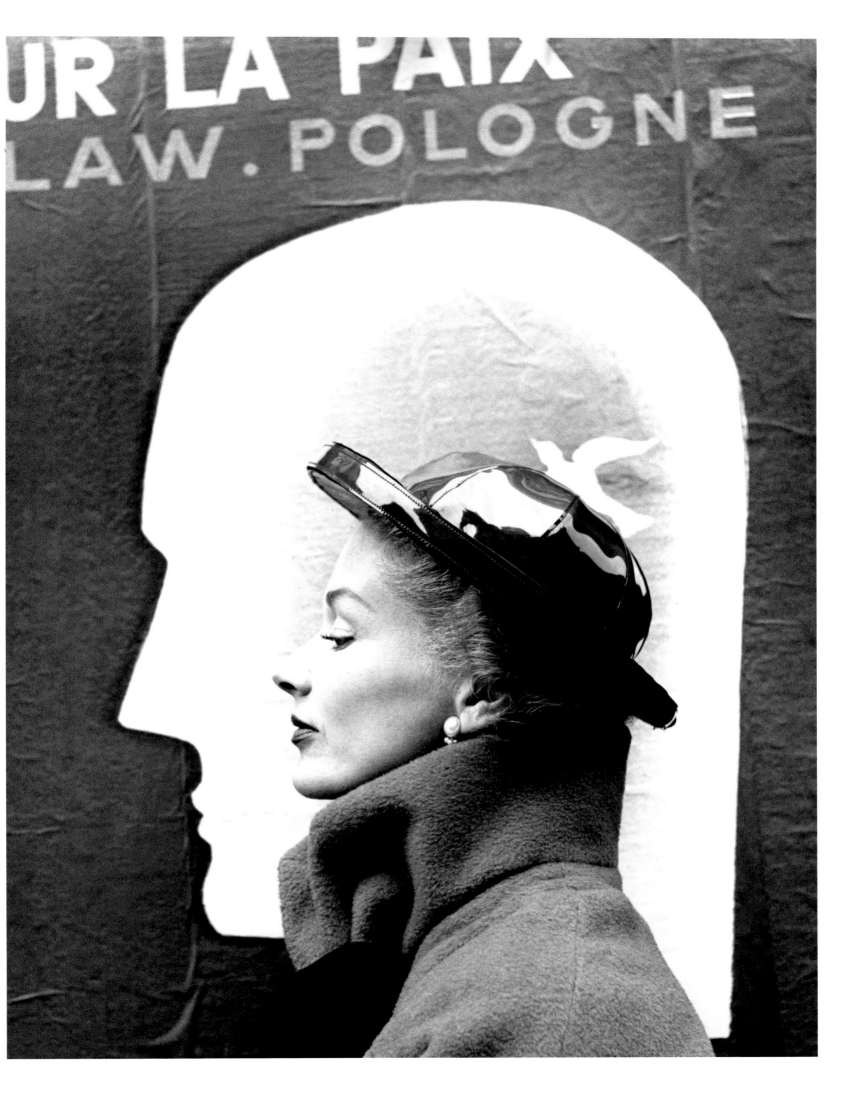

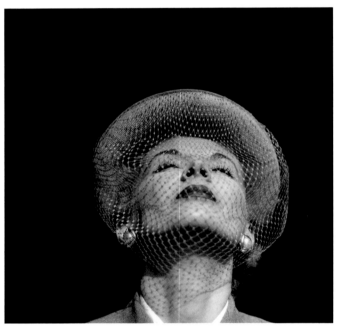

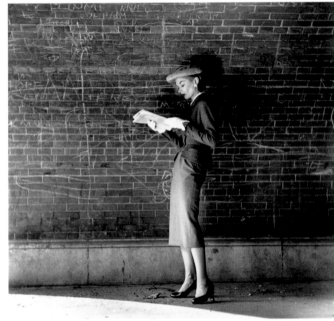

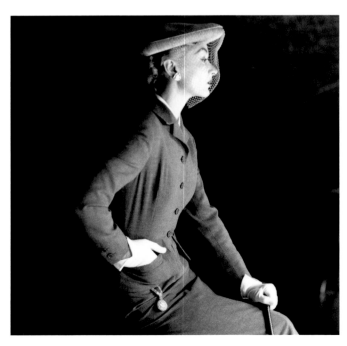

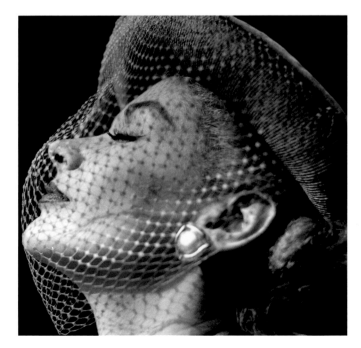

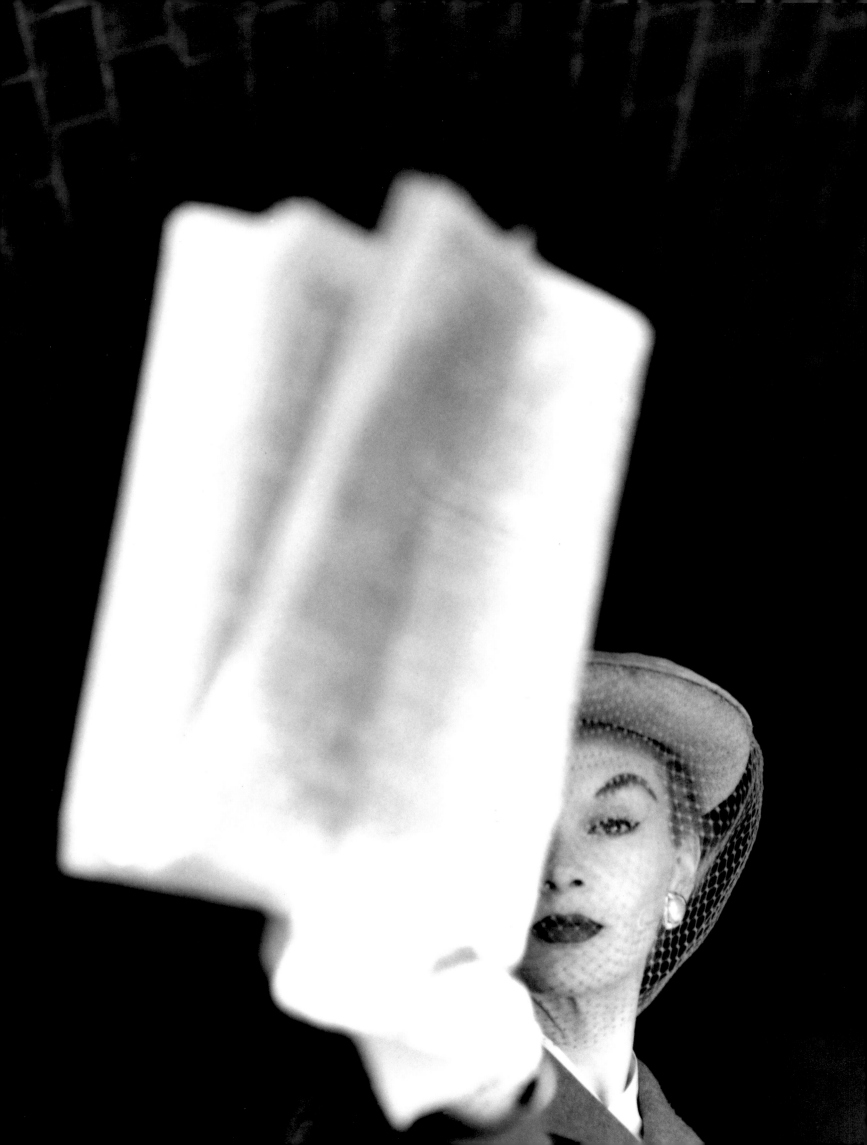

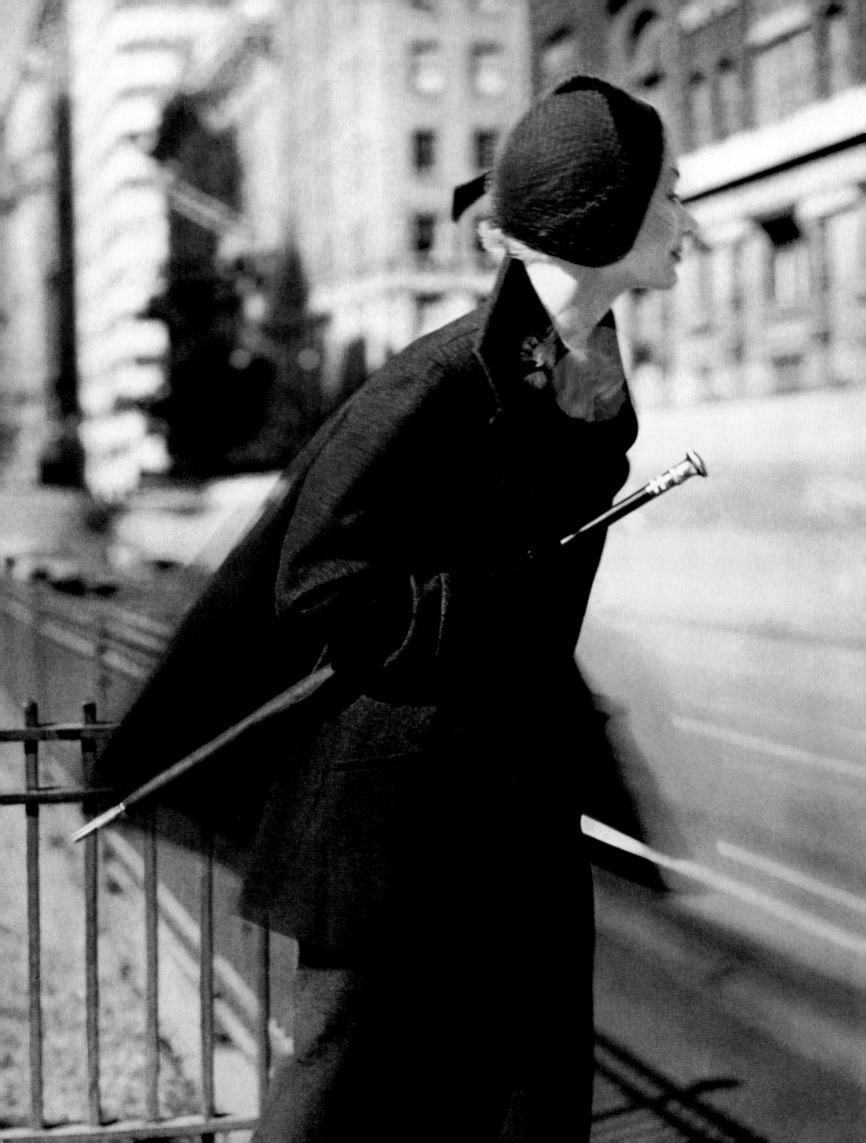

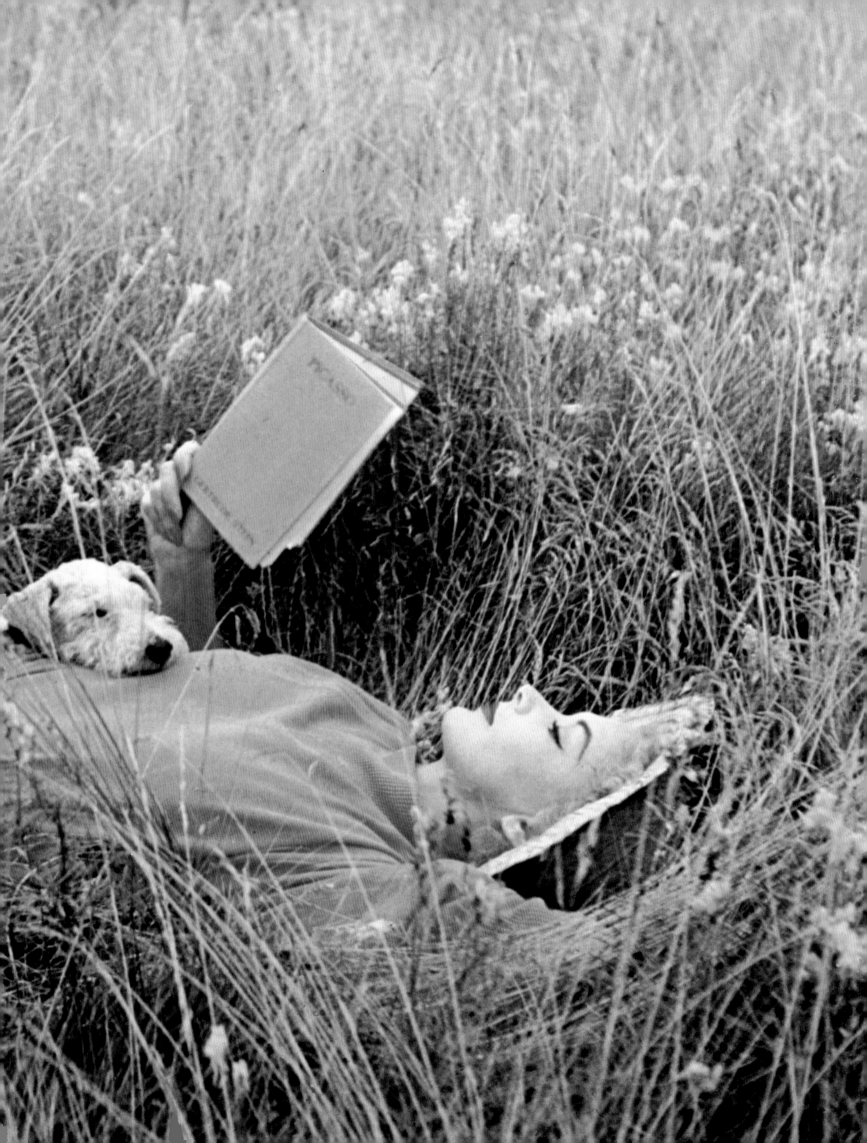

FRANCES MCLAUGHLIN-GILL

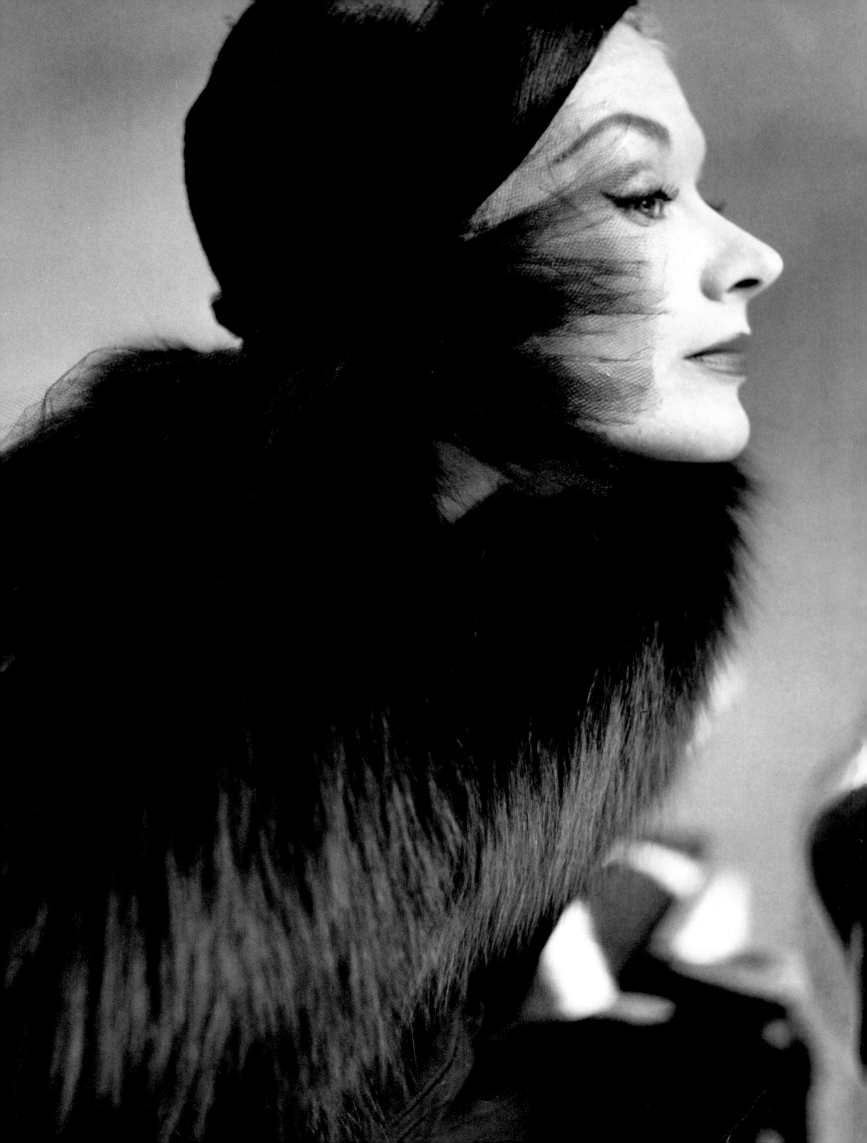

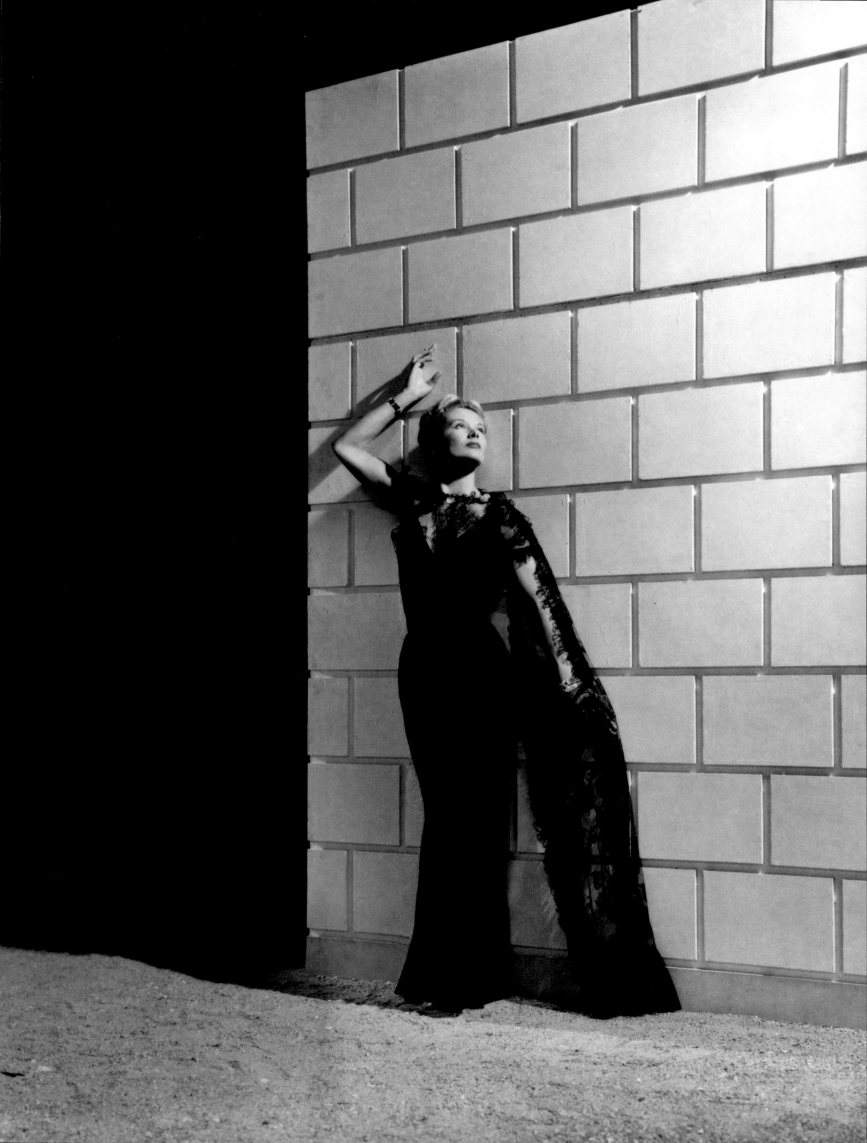

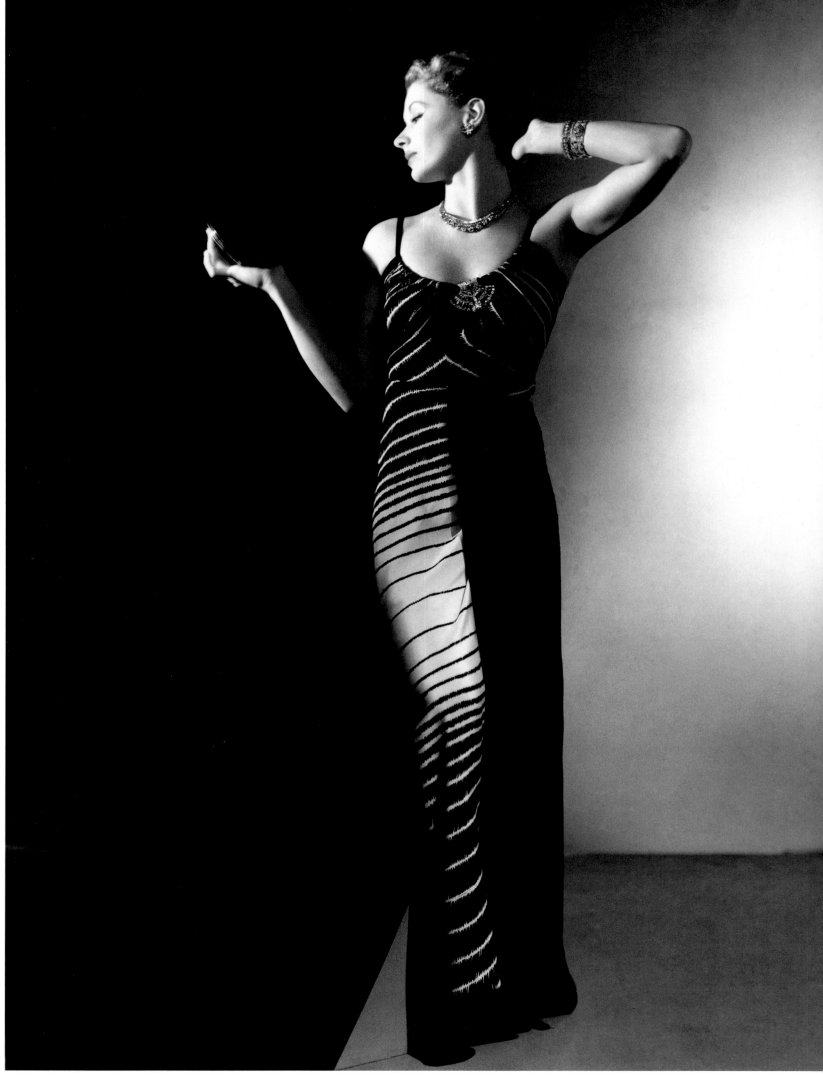

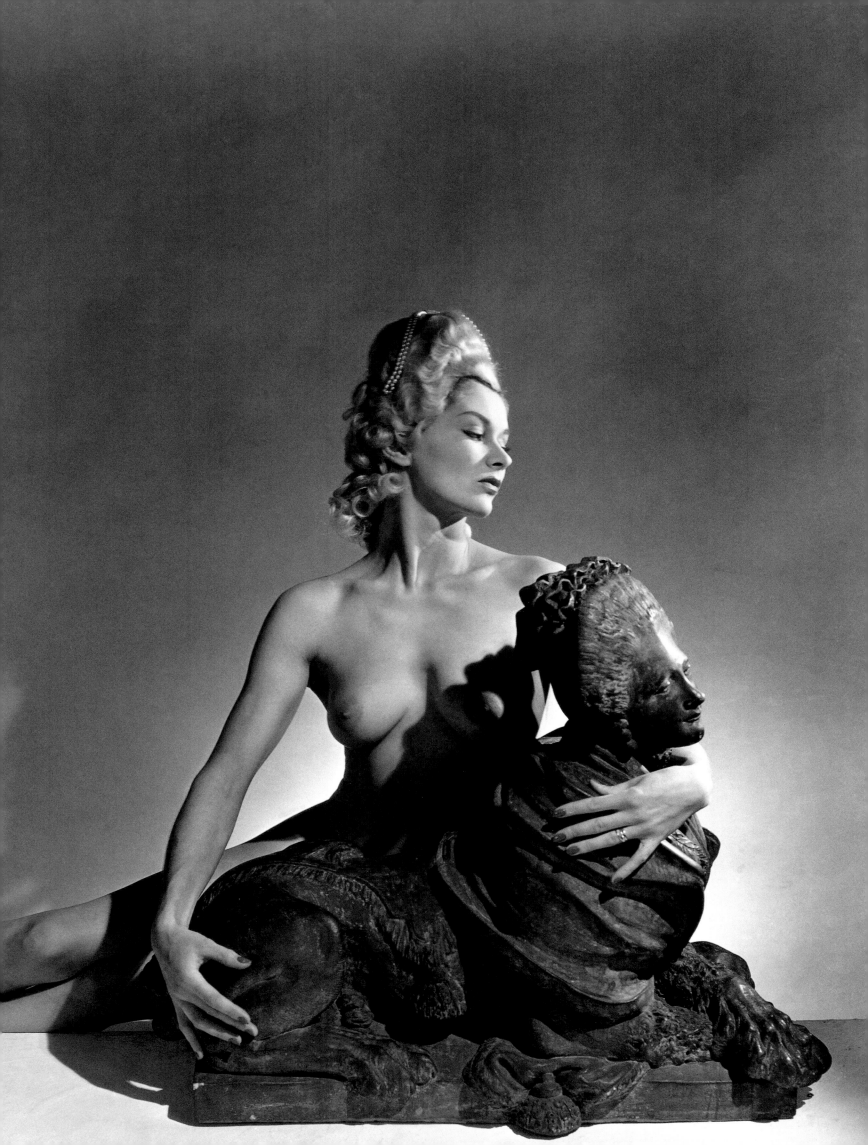

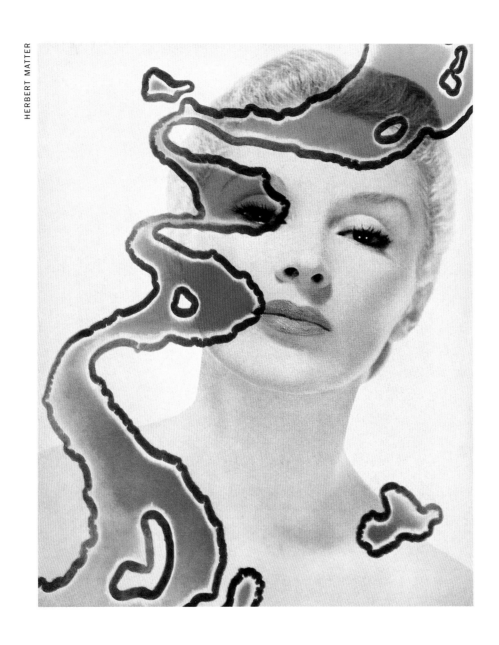

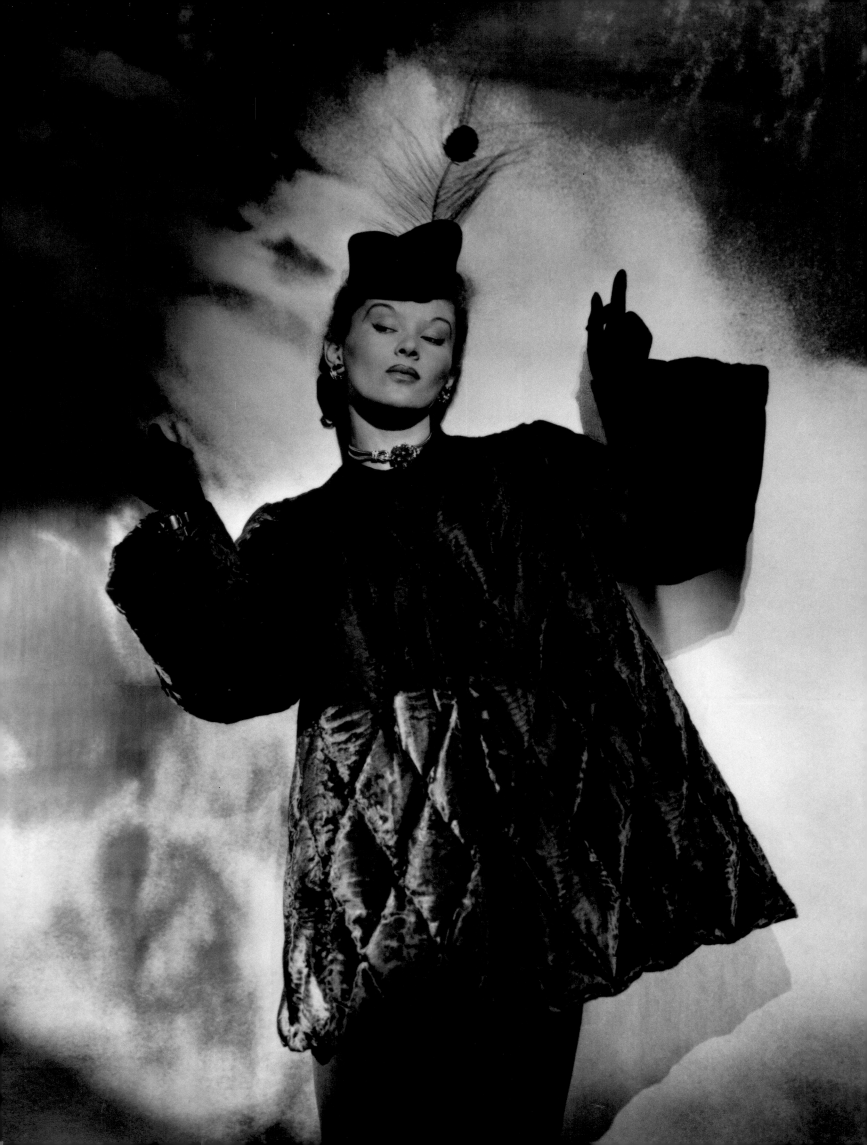

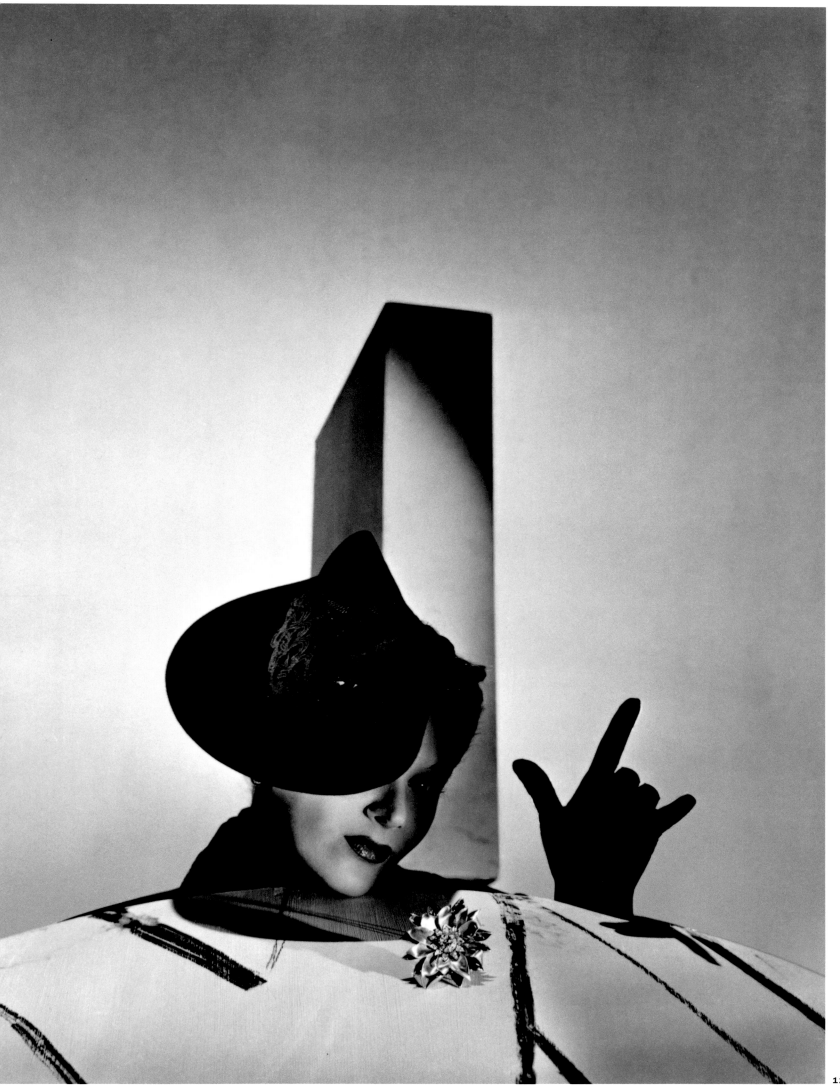

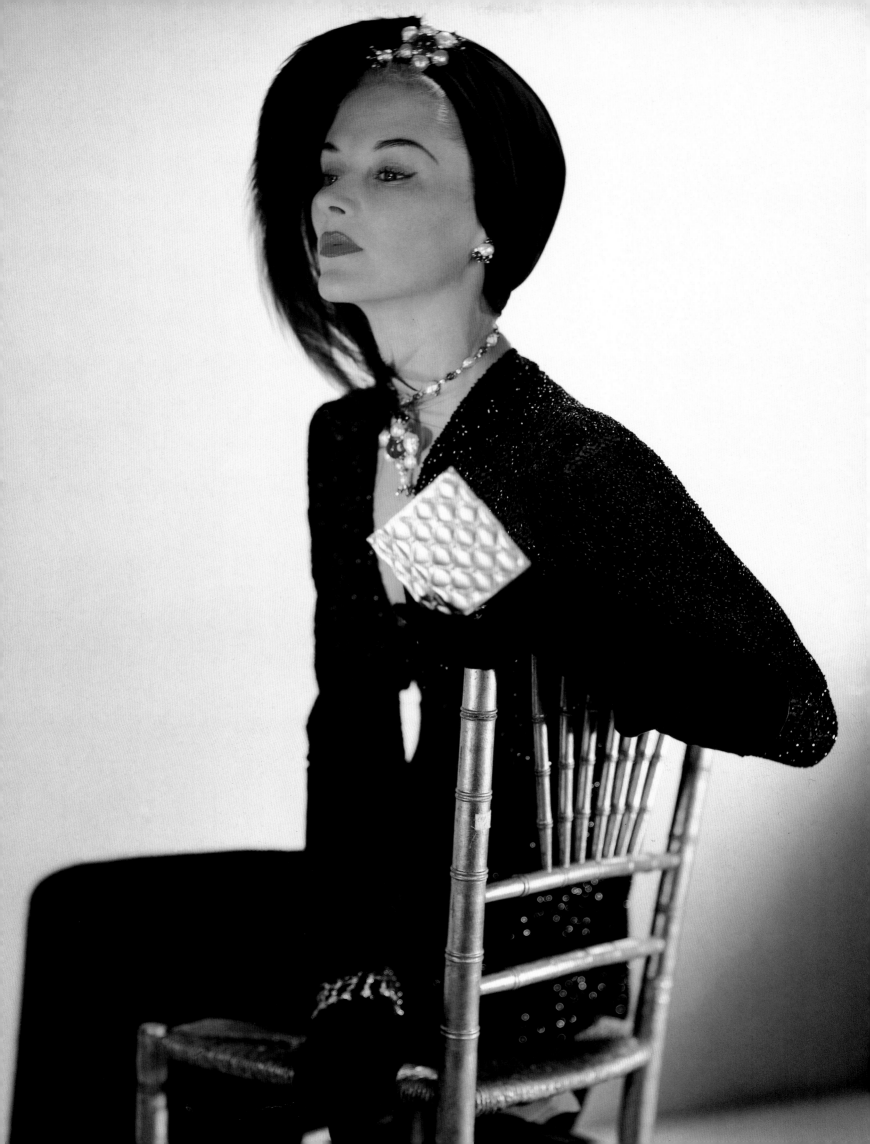

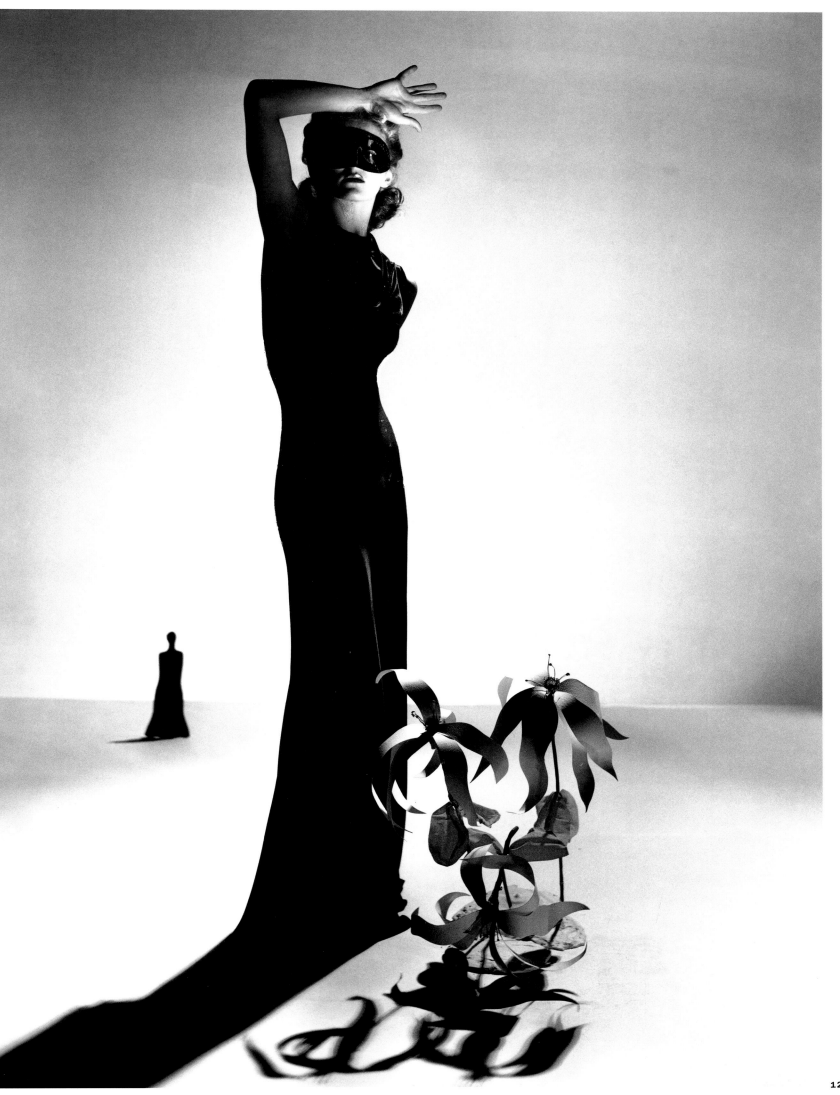

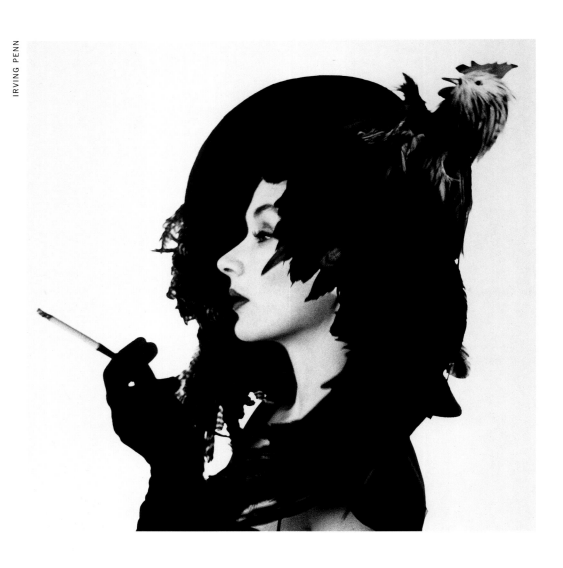

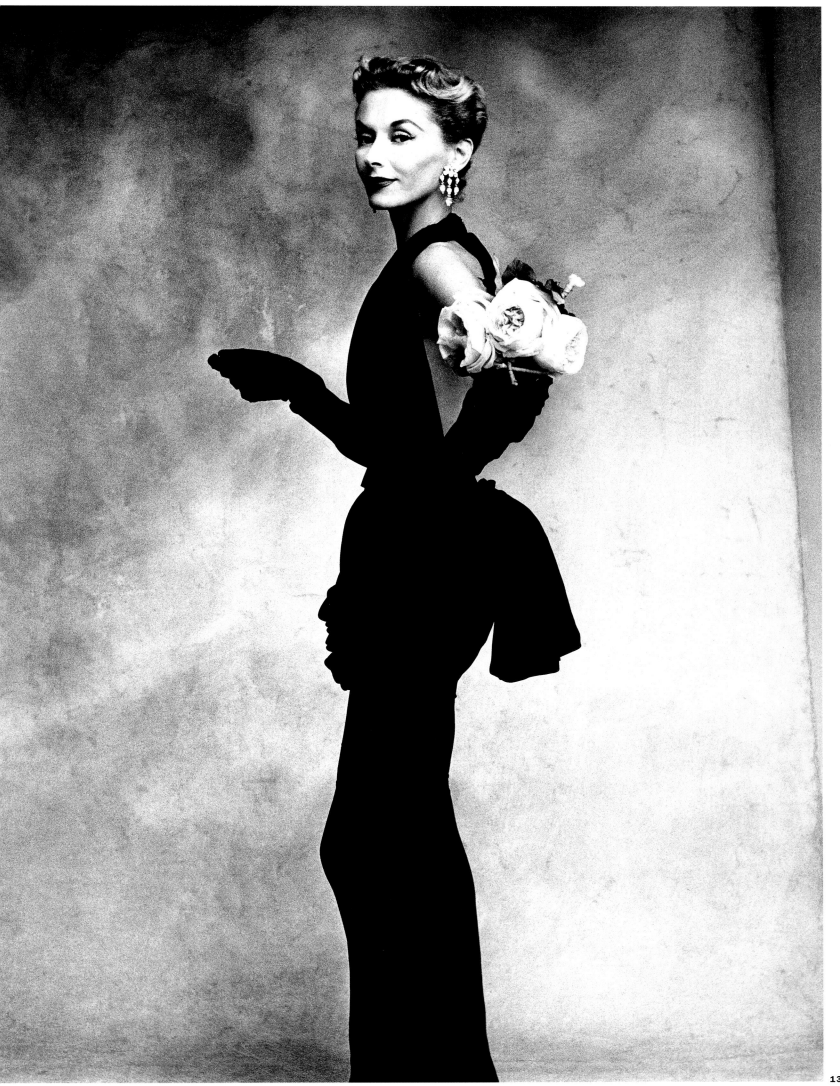

124 **ANDRÉ DURST** 1938
QUILTED BROADTAIL JACKET, MOLYNEUX
VOGUE 15 OCTOBER 1938

125 **HORST** 1938
TRICORNE HAT 'I LOVE YOU' BY SUZY
JEWELS BY BOUCHERON NEW YORK
VOGUE 1 AUGUST 1938

127 **HORST** 1940
'8 PM. PERFECTIONISM, MADE FOR AMERICA'
BY SOPHIE GIMBEL
VOGUE 1 SEPTEMBER 1940

129 **EUGENE RUBIN** 1937
FASHION BY ALIX PARIS
HARPER'S BAZAAR 1 SEPTEMBER 1937

130 **IRVING PENN** c. 1949
WOMAN IN CHICKEN HAT NEW YORK

131 **IRVING PENN** 1950
PLEATED CHIFFON EVENING DRESS BY LAFAURIE PARIS
VOGUE 15 SEPTEMBER 1950

133 **IRVING PENN** 1949
'HAMLET COIFFURE' NEW YORK
VOGUE 1 MARCH 1949

IRVING PENN

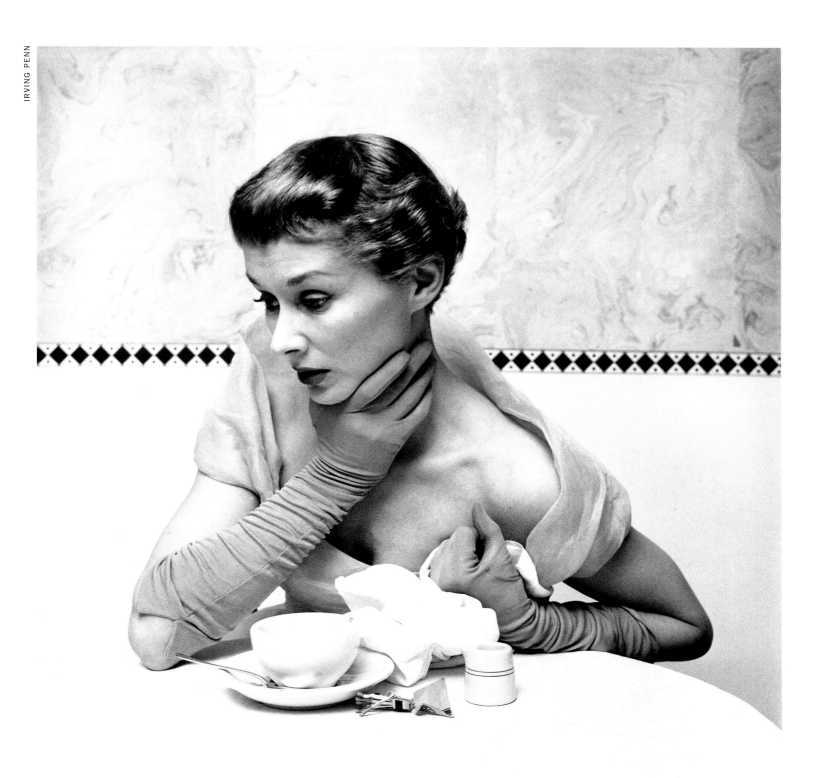

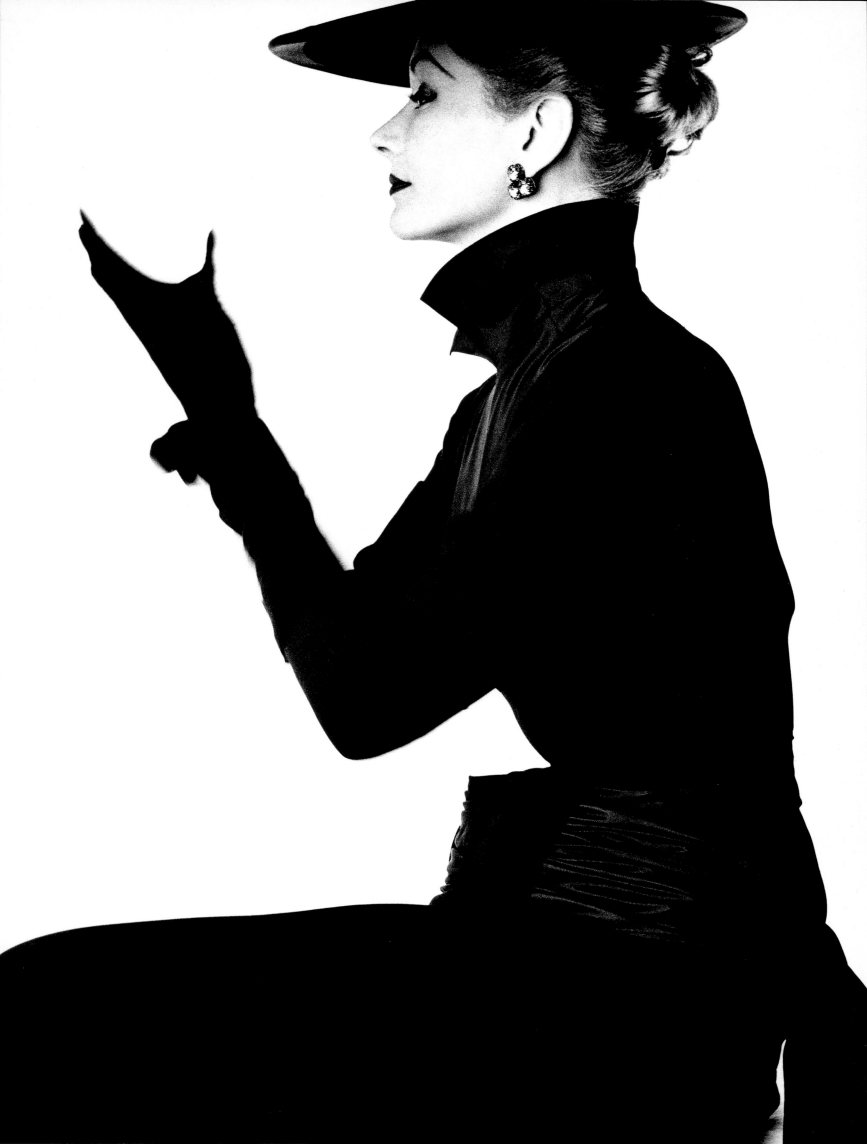

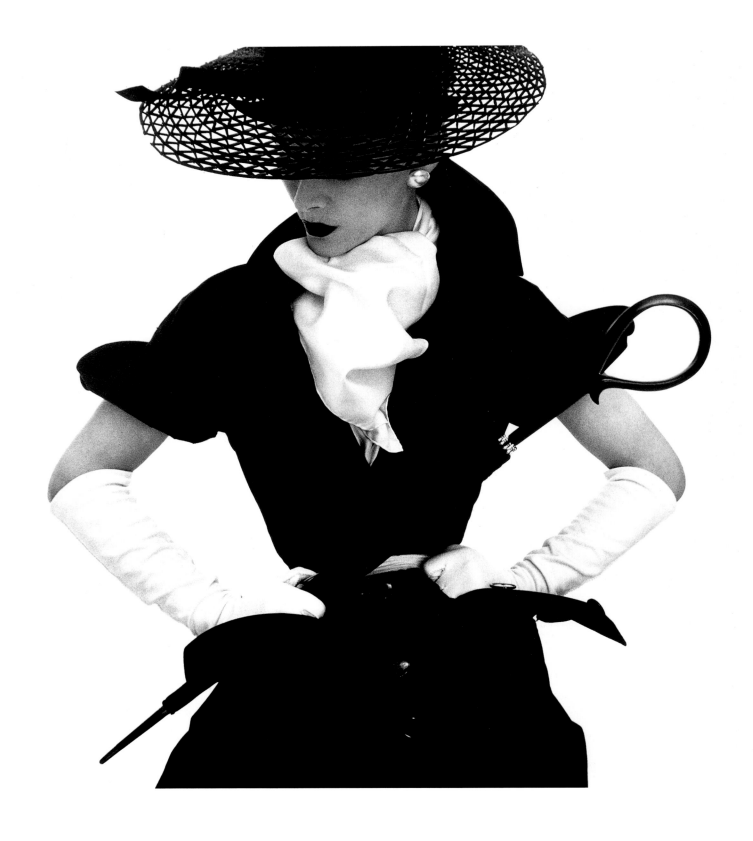

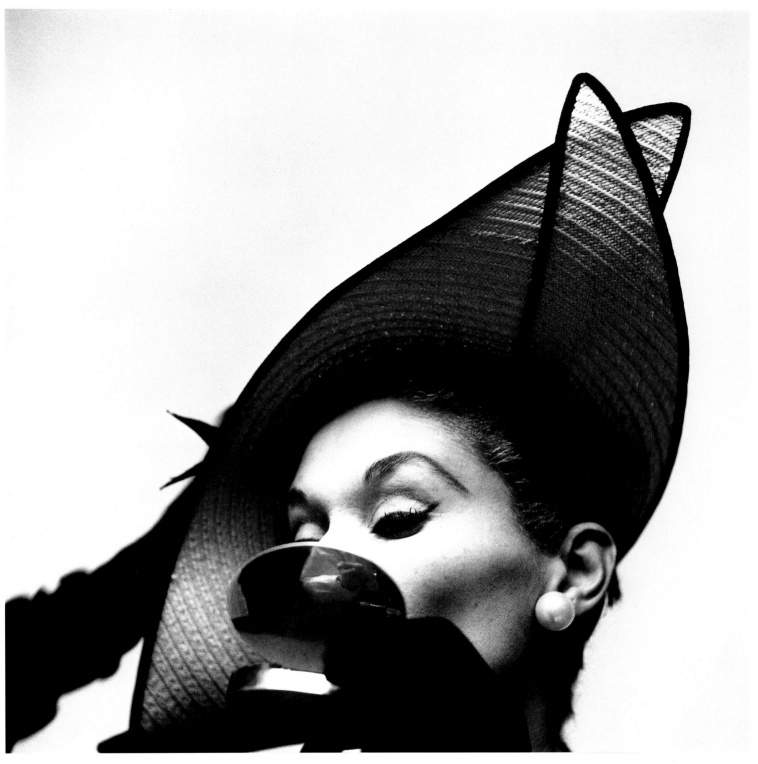

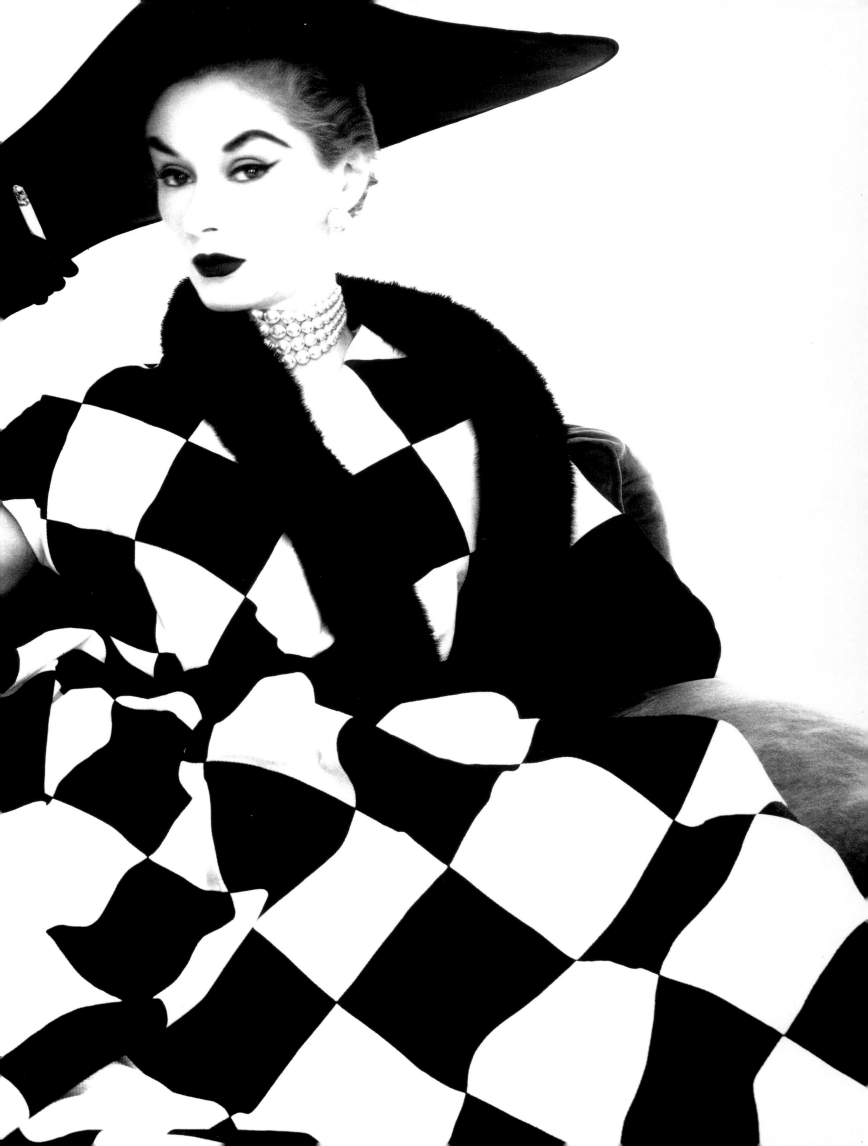

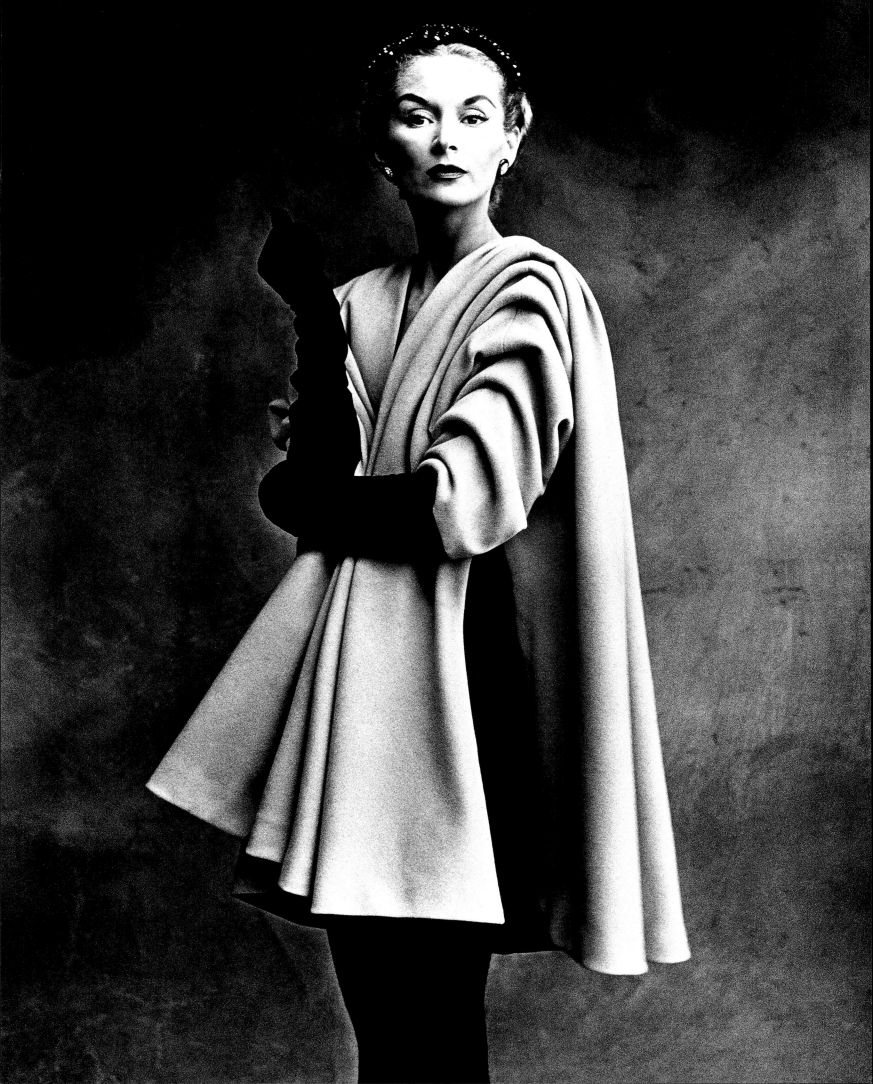

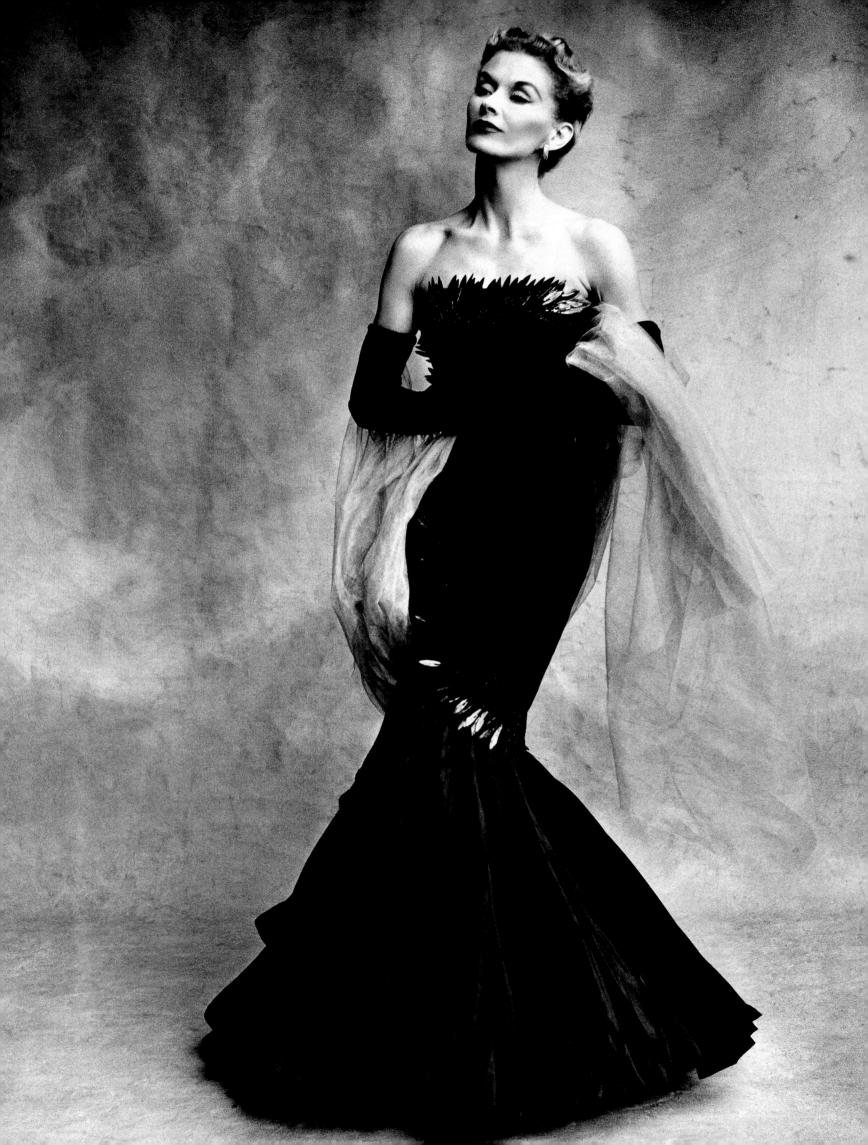

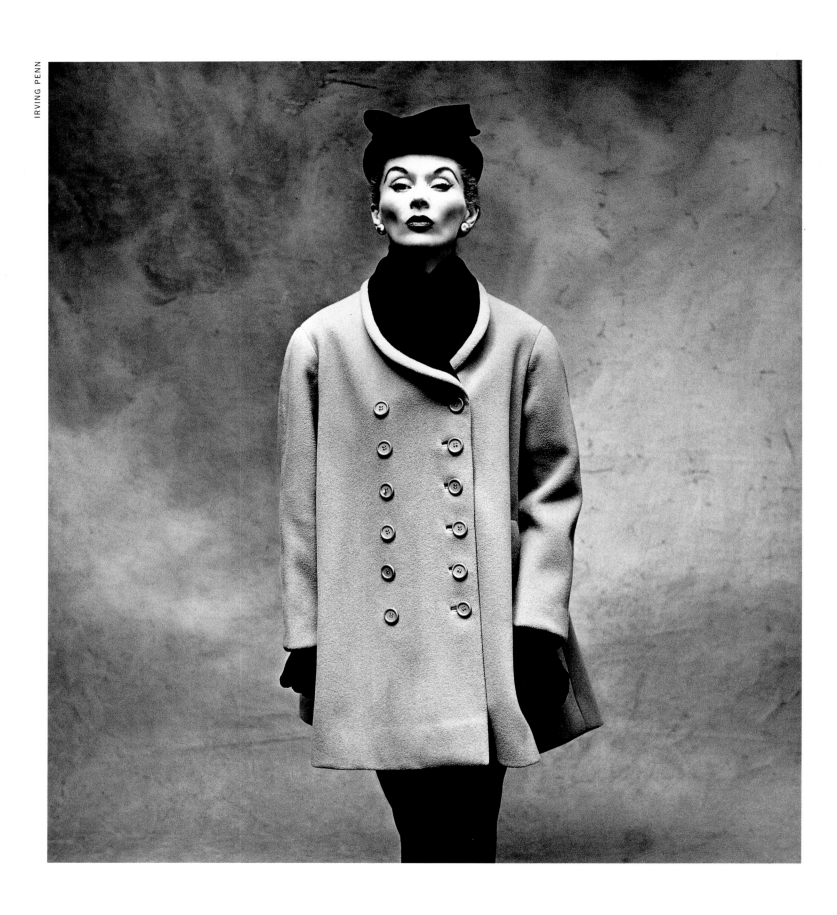

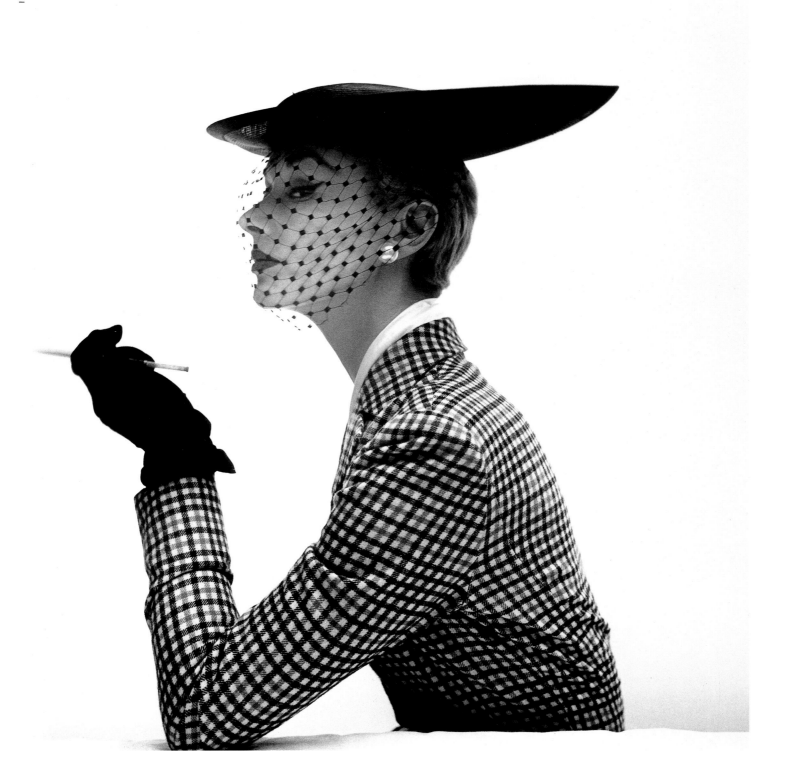

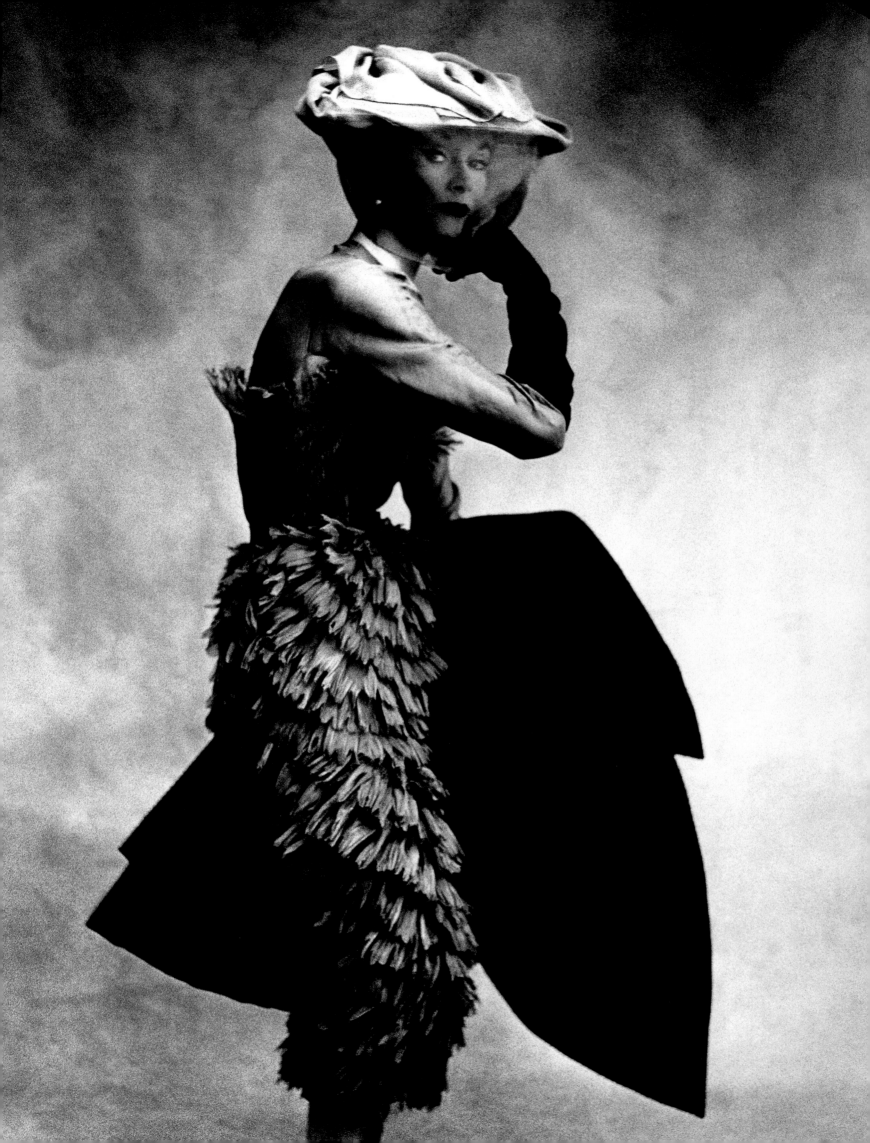

135 **IRVING PENN** 1952
FASHION BY JO COPELAND
VOGUE JULY 1952

136 **IRVING PENN** 1950
WOMAN WITH UMBRELLA, HAT BY LILLY DACHÉ NEW YORK
VOGUE 1 APRIL 1950

137 **IRVING PENN** 1949
 NEW YORK

138–139 **IRVING PENN** 1950
HARLEQUIN DRESS BY JERRY PARNIS NEW YORK
VOGUE 1 APRIL 1950

141 **IRVING PENN** 1950
FASHION BY BALENCIAGA PARIS
VOGUE 1 SEPTEMBER 1950

143 **IRVING PENN** 1950
FASHION BY MARCEL ROCHAS PARIS
VOGUE 15 SEPTEMBER 1950

144 **IRVING PENN** 1950
'LITTLE GREAT COAT' BY BALENCIAGA PARIS
VOGUE 1 SEPTEMBER 1950

145 **IRVING PENN** 1950
BICORNE SKIMMER BY LILLY DACHÉ NEW YORK
VOGUE 15 FEBRUARY 1950

147 **IRVING PENN** 1950
COCOA-COLOURED DRESS BY BALENCIAGA PARIS
VOGUE 1 SEPTEMBER 1950

149 **IRVING PENN** 1952
WOMAN IN DIOR HAT WITH MARTINI NEW YORK
VOGUE 15 FEBRUARY 1952

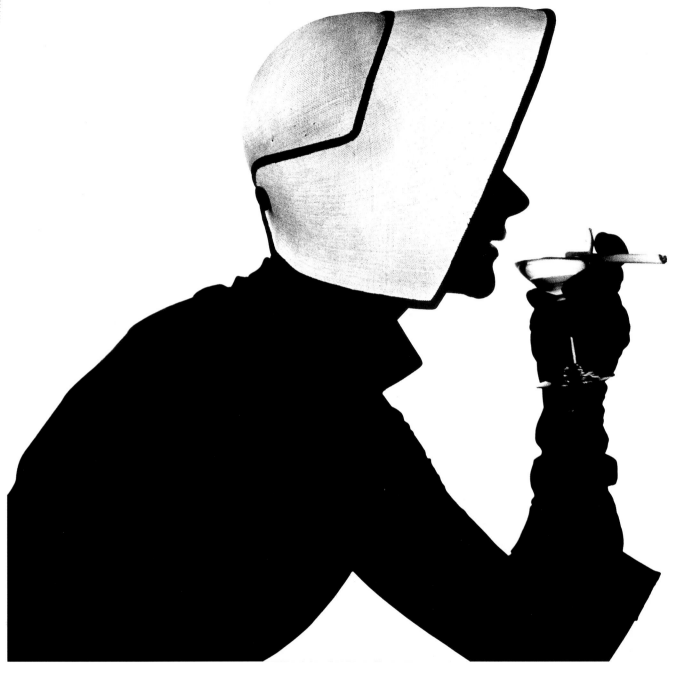

PHOTO CREDITS